For Tani Gail.
In hopes of sparks {

Merry Christmas '96
love
Curtis

The Arts & Crafts Metalwork of Janet Payne Bowles

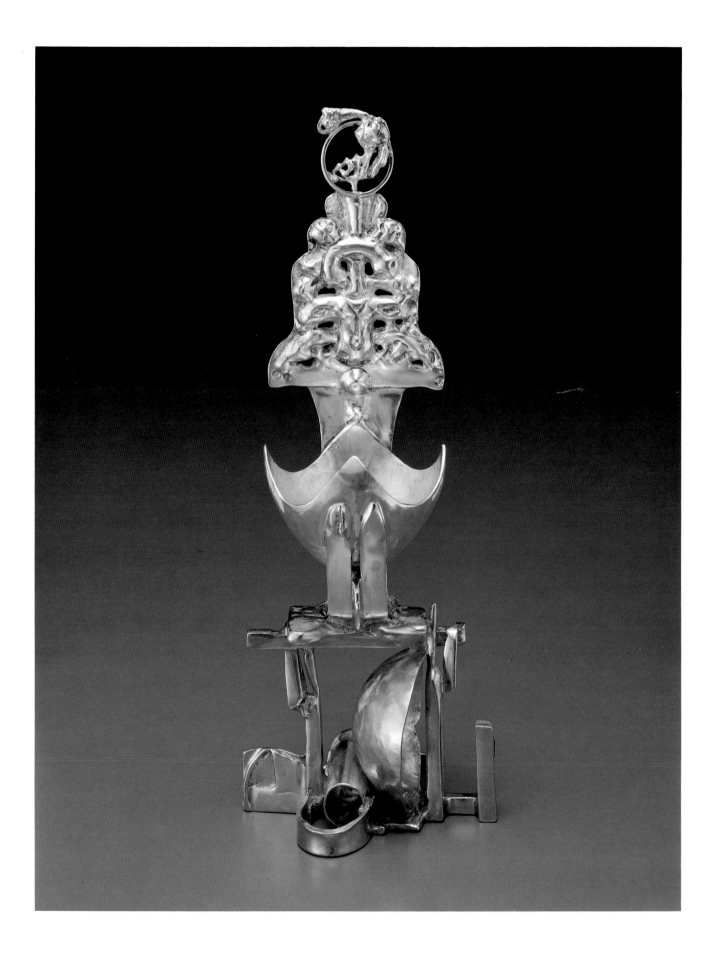

The Arts & Crafts Metalwork of Janet Payne Bowles

Barry Shifman

with contributions by

W. Scott Braznell and Sharon S. Darling

Indianapolis Museum of Art

in cooperation with

Indiana University Press

1993

Editor's Note

Both figures and plates are numbered consecutively
throughout the book. Plates illustrate objects
that are in the exhibition. Catalogue numbers refer
to the catalogue of the entire Janet Payne Bowles
Collection found on pages 117-125. Unless
otherwise noted, all photographs were supplied
by the owning collection or institution.

This book was published in conjunction with the
exhibition *The Arts & Crafts Metalwork of Janet
Payne Bowles.* The exhibition was organized by the
Indianapolis Museum of Art and has been made
possible by a grant from the National Endowment
for the Arts and a matching grant from the Indiana
Humanities Council in cooperation with the National
Endowment for the Humanities. Additional support
has been provided by The Herman Goldman
Foundation, the Indiana Arts Commission, and
the City of Indianapolis.

Exhibition Schedule

Munson-Williams-Proctor Institute Museum of Art
Utica, New York
September 4, 1993 – January 3, 1994

Indianapolis Museum of Art
Indianapolis, Indiana
April 9 – May 22, 1994

Library of Congress Catalogue Number: 93-77202
ISBN 0-936260-58-0

Published by the Indianapolis Museum of Art,
1200 West 38th Street, Indianapolis, Indiana, 46208.
Distributed by Indiana University Press, 10th and
Morton Streets, Bloomington, Indiana, 47405.

Cover: *Chalice*, ca. 1925-31 (cat. 122)
Frontispiece: *Font*, ca. 1925-29 (cat. 105)

Contents

Foreword 6

Preface 8

Janet Payne Bowles and the Arts & Crafts Movement in Indianapolis 11
Barry Shifman

From "New Woman" to Metalsmith: A Voyage of Self Discovery 27
Sharon S. Darling

The Metalcraft and Jewelry of Janet Payne Bowles 47
W. Scott Braznell

Chronology 111

Catalogue of the Janet Payne Bowles Collection 117

Selected Bibliography 126

Index 134

Foreword

It is easy to smile at the idealism of the Indianapolis high school jewelry shop teacher who, some sixty years ago, founded a student association—the Workmanship Guild—with the announced aim of "stimulating to life long endeavor the striving to be an honest, skilled, creative workman. . . ." The impetus for this transformative enterprise was to be "the experience of the jewelry shop," and the underlying credo was that "honesty in work is the true basis for honest character, enlightened mind, creative growth and personal happiness for the individual and civic purity for the community." However much we may admire Janet Payne Bowles's high-minded earnestness in founding this organization, her faith in the efficacy of art as an instrument of personal salvation and social order is apt to strike the modern reader as touchingly naive.

Nowadays, when affluent collectors furnish their homes with Mission Oak, and a Gustav Stickley sideboard brings thousands of dollars at auction, the links between hard work, personal character, and the redemptive quality of a well-designed chair are perhaps harder to credit than they were when the century was young. The belief that making and using simple, honest, straightforward domestic objects would inculcate parallel ethical and moral virtues sounds like wishful thinking. And yet it is a continuing strain in American life and thought.

In some respects the sixties efflorescence of small shops stocked with handmade pottery, weavings, jewelry, furniture, and leather goods was a recent manifestation of this recurrent American desire to reconcile life and art. And today's urgent calls from business leaders for an educational system that can once again produce young people imbued with the spirit of work—though perhaps inspired more by economic than ethical concerns—suggest that the need for the "honest, skilled, creative workman" is as great as ever.

Some of the recent experiments in American industry with "quality circles" and approaches to product manufacture that emphasize teamwork and reward initiative seem, in fact, not so far removed in spirit from the manifesto of Janet Payne Bowles's Workmanship Guild and the ethos of the American Arts and Crafts movement. The belief in the dignity of work and the importance of personal responsibility had its roots in the ideas and examples of two nineteenth-century English reformers, John Ruskin and William Morris. Ruskin, who was

arguably the most influential art critic ever to write in the English language, railed against a system of manufacture that deprived the workman of pride in his work. Morris put Ruskin's precepts into practice, designing and producing furniture, textiles, stained-glass windows, and printed books characterized by quality materials and workmanship and simplicity and integrity of construction.

The seeds broadcast by Ruskin and Morris fell on fertile soil in America. Arts and Crafts societies sprang up in this country from Massachusetts to California. As this catalogue demonstrates, Indianapolis was in the vanguard of the movement, having founded its own society in 1905. Janet Payne Bowles, whose life and work are chronicled here, became a leading figure on the Indianapolis Arts and Crafts scene after the turn of the century. The Indianapolis Museum of Art has the largest collection of jewelry and metalwork by Payne Bowles, and the importance of this body of work was quickly recognized by Barry Shifman, associate curator of decorative arts, who has organized the current exhibition and catalogue. Mr. Shifman's enthusiasm for this material, as well as his diligent and thorough research over a period of several years, has resulted in a glorious celebration of the American Arts and Crafts movement. I join with Mr. Shifman in thanking the other contributors to this catalogue, the lenders and donors whose cooperation has made this exhibition possible, and the individuals, businesses, and government agencies who have provided financial support.

Looking at the objects included in this exhibition—objects that speak of imagination, craftsmanship, and a pride in work well done—even the skeptical modern viewer may come to share at least the hope that in this country we can find a way to recover those virtues in our workplace and our daily lives. We could do worse than to reconsider John Ruskin's words, words that became a rallying cry for the American Arts and Crafts movement:

> *It is only by labor that thought can be made healthy, and only by thought that labor can be made happy, and the two cannot be separated with impunity. It would be well if all of us were good handicraftmen in some kind, and the dishonour of manual labor be done away with altogether.*

Bret Waller
Director
Indianapolis Museum of Art

Preface

Shortly after arriving at the Indianapolis Museum of Art, I became intrigued by the museum's collection of one hundred and twenty-five objects made by the Arts and Crafts metalsmith Janet Payne Bowles. I had already seen a sampling of Payne Bowles's work in the single object by her displayed in the 1987 exhibition *The Art That is Life*, held at the Museum of Fine Arts, Boston, and I was compelled to find out more about this unusual artist. The deeper I delved into the collection, the more determined I became to organize an exhibition and write a definitive catalogue on the life and work of Janet Payne Bowles.

From only about ten newspaper clippings on Payne Bowles, the body of research materials grew to include numerous photographs of Payne Bowles, of her children Mira and Jan, of objects crafted by her, and of exhibition installations. The archives of the Indianapolis Museum of Art soon contained many articles concerning her activities that had appeared in the various Indianapolis newspapers. A local high school paper, the *Shortridge Daily Echo*, would become a major resource for the present catalogue and exhibition. Jerome Sikorski, a former employee in the education department of the museum, took a keen interest in Payne Bowles's work: he wrote a master's thesis entitled "Out of Indianapolis: Janet Payne Bowles, Goldsmith," and when Mira and Jan Bowles donated their mother's jewelry and metalwork to the museum in 1968, Mr. Sikorski interviewed Mira several times about her mother.

With these resources available, I consulted with Sharon S. Darling and W. Scott Braznell, two acknowledged experts in the field of decorative arts, who agreed that the material warranted an exhibition and catalogue. They made full use of the material gathered in the Janet Payne Bowles Archives, and I am indebted to them for their superb essays in this catalogue. I am also grateful to Mr. Braznell for assisting in dating the works by Janet Payne Bowles. Edward S. Cooke, Jr., the Charles S. Montgomery Associate Professor of Art History at Yale University, and Eileen C. Boris, professor of history at Howard University, read and evaluated all of our essays, and I thank them for their thoughtful suggestions.

The staff of the Indianapolis Museum of Art was instrumental in bringing this project to fruition. I am especially grateful to Bret Waller, director of the

Indianapolis Museum of Art, and to Ellen Lee, chief curator, both of whom have been supportive and enthusiastic about the project. They both believed in the significance of Janet Payne Bowles and allocated funds for research. Harriet G. Warkel, curatorial assistant, undertook a wide variety of tasks including proofreading, updating notes and research, tracking down photographs, and making suggestions with regard to the manuscript. Her tireless efforts throughout the project are greatly appreciated. Thanks also to Martin Krause, curator of the department of prints, drawings, and photographs, for sharing with me his knowledge about Indianapolis at the turn of the century.

Many thanks to the registration department, and especially to Vanessa Burkhart, registrar. I am also grateful to the exhibits department, particularly to Sherman O'Hara, chief designer, and Andrew Michael Bir, who provided the mounts for the objects. Martin J. Radecki, chief conservator and curatorial services division administrator, and Hélène Gillette, associate conservator of objects, were most helpful throughout the project. Ms. Gillette analyzed and conserved many of the objects in the Janet Payne Bowles Collection, and she identified the materials used in each object. I would also like to thank Jeanmarie Easter, conservation technician, and Dr. Louis Nie for spending many hours cleaning the objects in the collection.

Elizabeth A. Pratt edited the catalogue with sensitivity and insight, and her wise counsel and experience have been greatly appreciated. The elegant design was achieved with great patience and attention to detail by Elizabeth Finger. Stephen Kovacik, former museum photographer, and especially John A. Geiser, the museum's photographer, spent many weeks producing the photographs for this publication. Ruth Roberts, photographer's assistant, also deserves my appreciation. Thanks also to Jane Graham, publications manager, for coordinating all aspects of the catalogue, and to Craftsman Type Inc. for the fastidious typesetting of the text. I would also like to thank Susan L. Albers for the hours she spent developing grants for the catalogue and exhibition.

A word of thanks to Jerome Sikorski for the use of his initial research on Janet Payne Bowles; he kindly answered questions and supplied photographs. Grace Ferguson Haugh, Laura Sheerin Gaus, Frank Lobraico, Lenos Marshall, and Arthur Ellis are to be thanked for their participation in the Janet Payne Bowles oral history session held in 1991. The staff of the Indiana State Library, the library at the Indiana Historical Society, the Indianapolis Public Library, and the library of the Indianapolis Museum of Art all provided assistance in my research. Finally, I thank Sue Ellen Paxson for her friendship and encouragement.

Barry Shifman
Associate Curator of Decorative Arts
Indianapolis Museum of Art

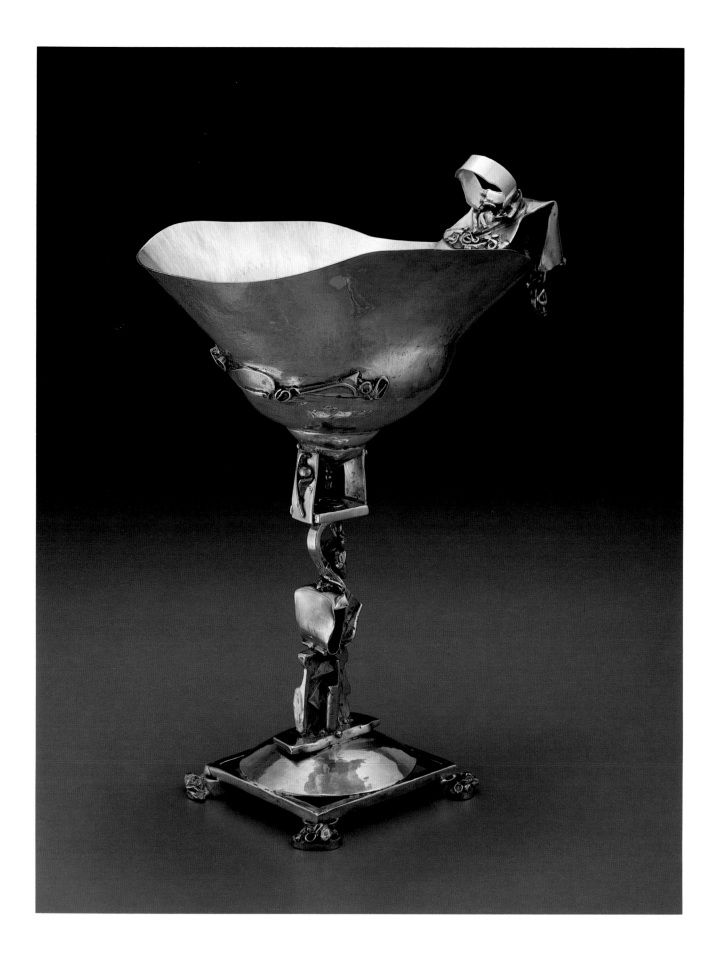

Janet Payne Bowles and the Arts & Crafts Movement in Indianapolis

by Barry Shifman

In the late 1880s and early 1890s, the art community in Indianapolis was profoundly influenced by John Ruskin, William Morris, and the English Arts and Crafts movement. A strong commitment in this midwestern city to the ideals established by Morris fostered considerable activity in the applied arts: a stress upon crafts in school curricula; the establishment of arts organizations; and a proliferation of artistic products. Janet Payne Bowles (1872/73-1948) and her husband, Joseph Moore Bowles (1866-1937), were among a group of talented Indianapolis residents who responded to Morris's philosophy and contributed to its interpretation.

Janet Payne (Fig. 1) was born in Indianapolis on June 29, 1872 or 1873. As a student at Indianapolis High School (renamed Shortridge High School in 1897) from 1887 through her graduation in 1890, Janet displayed a special interest in music. She studied piano with Clarence Forsyth (1859-1912), a composer and teacher who founded the Indianapolis School of Music in 1889. She also took art classes taught at Shortridge by Roda Selleck, who would prove to be an important influence on Payne Bowles and on the Indianapolis art community.

At the end of her high school years, Janet Payne met Joseph Bowles (Fig. 2), who played an especially active role in launching the Arts and Crafts movement in Indianapolis in the late 1880s. In 1888, he ran a short-lived art gallery, which mainly featured watercolors, etchings, and paintings.[1] From 1890 to 1895, he was a clerk at H. Lieber Company, an emporium which sold works of art, artist's materials, frames, and photographic supplies.[2] He was also one of the early members of the Art Association of Indianapolis, founded in 1883, and served on its board of directors from 1892 to 1895. The association often held various art exhibitions at H. Lieber Company and elsewhere, including a display in 1892 of textiles by William Morris.

Joseph Bowles was a founding member of the Portfolio Club, established in 1890, which brought together most of the leading artists, architects, writers, teachers, and musicians in Indianapolis to "study the various branches of art ... to bring the various art interests of the community together, and promote a spirit of art interest and art appreciation."[3] Members presented papers, organized exhibitions, and supported each other in their artistic or literary pursuits.

Plate 1. *Chalice*, ca. 1925-28 (cat. 103)

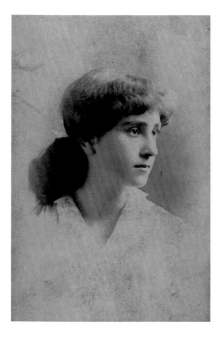

Fig. 1. Janet Payne, ca. 1887. Photo: Indianapolis Museum of Art.

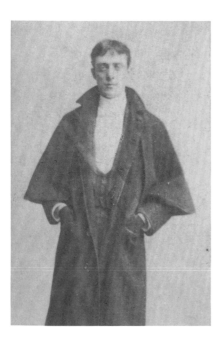

Fig. 2. Joseph Moore Bowles, ca. 1890. Photo: Indianapolis Museum of Art.

Bowles was responsible at the outset for bringing the English Arts and Crafts movement to the attention of the club. He was instrumental in organizing a number of lectures and exhibitions, sponsored by both the Portfolio Club and Indianapolis's Art Association, that presented English decorative arts (some from Bowles's own collection) and the work of William Morris and Aubrey Beardsley.

In 1893, Joseph Bowles published the first issue of *Modern Art* (see Fig. 3), one of the earliest and most influential journals of the American Arts and Crafts period, and the first illustrated quarterly magazine of modern art to appear in the United States.[4] Bowles was a "sensitive editor who anticipated the printing revolution and made *Modern Art* into one of the major vehicles for spreading the doctrine of printing as an art."[5] He paid particular attention to the design and production of *Modern Art*, and his esteem for William Morris is clearly reflected in the journal. Morris's own Kelmscott Press, begun in 1891, produced a series of small volumes, which Bowles is known to have purchased directly by mail from Morris. Bowles probably showed these books at the Portfolio Club to the young Bruce Rogers, who later became a distinguished book designer in the style of Morris. In 1893, Bowles commissioned Rogers to design the title pages, initial letters, and ornaments for the periodical.[6]

Bowles also commissioned Rogers to design the headbands, initials, and title page of a book on the collection of paintings owned by William T. Walters of Baltimore, father of Henry Walters, founder of the Walters Art Gallery. In 1895, Bowles published *Notes: Critical & Biographical. Collection of W. T. Walters*, by R. B. Gruelle. It was based on a number of articles which had appeared earlier in *Modern Art*, and was designed in the style of the Kelmscott Press editions and of *Modern Art*. Bowles in fact sent some page proofs to Morris for his criticism, and the decorations are clearly based upon the Kelmscott books.

In 1894, Janet Payne became a member of the Portfolio Club, and in October 1895 she married Joseph Bowles. Earlier that year, the prominent Boston lithographers Louis Prang and Company had acquired *Modern Art*; and shortly after their marriage the Bowleses moved to Boston, where Joseph continued as editor of the journal.

With her husband busy on *Modern Art*, Janet Payne Bowles was free to pursue her own interests. She intended to study piano, but other activities soon intervened. She began attending lectures in psychology and philosophy given by William James at Radcliffe; she continued to do so for the next five years, and psychology would prove to be a lifelong interest for her.[7] Janet commented about this period in her life:

> . . . I realized that I had not found the work into which I could throw all of my energy and enthusiasm, and that, unless I did, I would be disappointed in whatever I might undertake. The only work that counts . . . is, of course, that which affords one the opportunity for complete and satisfying self-expression.[8]

During her days as a student, Payne Bowles explored various areas of the city, including the wharves and wholesale districts, where she met a Russian

PLATE 2

The Second Epistle of John
1901
cat. 1

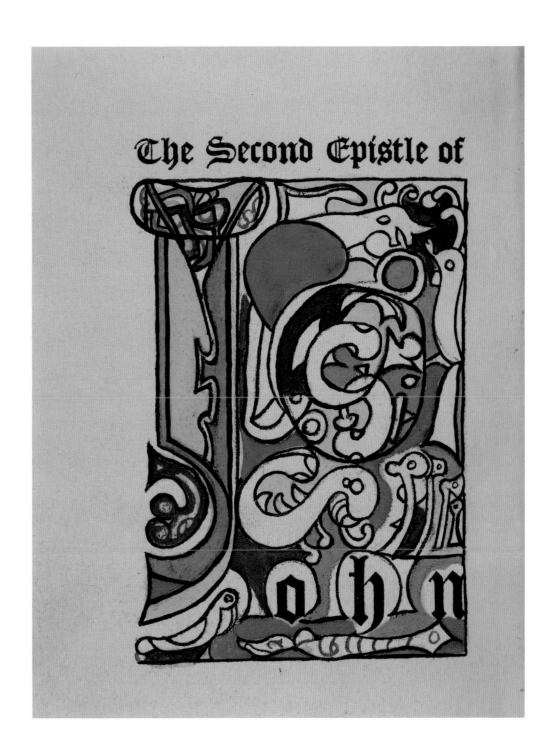

metalsmith whom she persuaded to teach her the fundamentals of metalmaking. She repeated the story often:

> One day I was walking along and heard an orchestral tone which was the most beautiful thing I had ever heard. I traced it to a basement room and found a young Russian metalworker. I asked him a lot of questions and he said, "If you are so curious get me a pail of water, help me." Though scalded by the steam, I stayed and helped and watched. We made a bargain—I was to teach him psychology and he would teach me metalsmithing.[9]

Payne Bowles soon set up a small studio in her own home to produce metalwork while trying to gain further experience:

> From that time on, I kept at it, working in every sort of shop that would give me a wider training. I even paid for the privilege of working in one shop, where they refused to employ me because I was an apprentice in the trade. I went to a foundry and learned the processes used there, and I served an apprenticeship in a manufacturing jeweler's shop. I studied stone cutting as well as metallurgy, and, of course, I always studied design.[10]

She also busied herself writing reviews for her husband's periodical, *Modern Art*, as well as creating book illuminations. Some of the illuminations were for *The Second Epistle of John* (see Pl. 2), a limited edition of fifty books on parchment and fifteen on English handmade paper published in 1901 by her husband. In 1897, Joseph was able to exhibit graphics from *Modern Art* and other printed materials at the *First Exhibition of the Arts and Crafts* of the Boston Society of Arts and Crafts. He wrote and published an article about the exhibition in the winter 1897 issue of the journal.[11]

In 1902, the Bowleses moved to Rye, New York. That year, Joseph had taken a position, which he retained for two years, as manager of the art department at *McClure's Magazine*. In the same year, their daughter, Mira, was born; a son, Jan, was born two years later, in 1904. During her years in New York, Janet studied the methods and designs of ancient Egyptian, Greek, and Asian metalwork at The Metropolitan Museum of Art, and she attended lectures in psychology given by John Dewey at Columbia University. Between 1905 and 1906, the Bowleses lived at an artists' community in Leonia, New Jersey.[12]

The family moved to Helicon Hall, formerly a fashionable residential boys' school, in Englewood, New Jersey, in late 1906 or early 1907. Upton Sinclair had purchased Helicon Hall with the royalties from his book *The Jungle*.[13] The building was set upon nine and a half acres of wooded property and Sinclair soon transformed it into a cooperative artists' colony or, as one writer called it, "an experiment in high-minded communal living."[14] There were about forty adults and fourteen children living in the complex, and the amenities included a swimming pool, bowling alley, and theater, as well as a large, glass-covered atrium in the center of the hall. The balconies around the atrium led to about fifty bedrooms. Each family occupied their own living quarters but ate in a communal dining room.

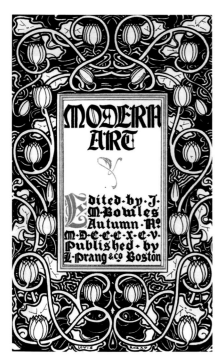

Fig. 3. Title page of *Modern Art*, Autumn 1895, edited by J. M. Bowles. Indianapolis Museum of Art.

The contemporary press often referred to Helicon Hall as a "socialist" colony. In truth, the residents were a diverse group, including, in Sinclair's own words:

> ...professors, journalists, doctors and lawyers among [the] members, [and] the question of belief or politics does not come up at all. In fact, there are some strictly business people in the venture, people who have old-fashioned, conservative ideas. There will always be room for compromise, you know, and the whole colony will be run simply as one big happy family—an experiment for which the world has long waited.[15]

One writer also commented that "membership implied no central political commitments but represented all varieties of radical opinion and shaded over into lunacy; there were socialists, anarchists, syndicalists, single-taxers, New Thoughtists, Spiritualists."[16] A young Sinclair Lewis swept the floors and stairways and tended the furnace; and John Dewey and William James were frequent guests at the colony.

After a fire destroyed the hall on March 16, 1907, the Bowleses moved to New York City.[17] In 1907, Joseph Bowles founded the Forest Press and Janet opened her own shop in the same location.[18] She frequented The Metropolitan Museum of Art where, in 1908, she had the opportunity to observe a group of Japanese metalworkers who were occupied in the cleaning, repairing, and re-installation of the important collections of Japanese armor, metalwork, and woodwork.[19]

In the course of her visits there, Janet made the acquaintance of Sir Caspar Purdon Clarke, director of the museum from 1905 to 1910. Payne Bowles described her meeting with Clarke in the museum's galleries:

> I was looking at some Greek things when a man who was standing close to me said, "I wonder how those are made," and proceeded to give his theory. I said, "No, I am sure they are done this way—for I have done some myself." He looked at me a minute and asked if I had made those things [necklaces] around my neck. I said I had and he wanted to know if I could duplicate one of them for him....[20]

Clarke regarded Payne Bowles's necklaces on a par with Etruscan metalwork and he purchased a number of objects from her during the course of their friendship.[21] He proved instrumental in introducing her to a number of important art patrons in New York, including J. Pierpont Morgan, who, from 1909 until 1913, is said to have commissioned many pieces from Payne Bowles.[22] In introducing Payne Bowles to Morgan, Clarke wrote to him in a letter: "The vital art of goldsmithing of the ancients has come up like a lost river in America in Janet Payne Bowles."[23] Janet later spoke about the commission:

> [Clarke] introduced me to Mr. Morgan and for four years I worked on nothing but pieces for his collection. He was a connoisseur on handwrought jewelry and service and all I did was the work itself, for he furnished all the gold and jewels.[24]

Payne Bowles began to exhibit her work, and in 1909 she was reported to have won the Spencer Trask Prize.[25] A successful Wall Street banker, Spencer Trask

was the president of the National Society of Craftsmen and chairman of the National Arts Club. A photograph in the Indianapolis Museum of Art is annotated "Spencer Trask prize, 1909 (about)": it is possible that the annotation refers to Janet's participation in the third annual exhibition of the National Society of Craftsmen in December 1909,[26] but there is no other information about this seemingly important episode in her career. Documentation does exist, however, indicating that she exhibited in the Society's show the following year.[27]

Early in 1910, Payne Bowles was commissioned by the artist John Alexander, who was in charge of costumes and stage designs for the celebrated stage actress Maude Adams, to design and execute jewelry for the actress's role as Rosalind in Shakespeare's *As You Like It* (see Fig. 4). The objects Janet created were of carved silver set with green onyx and included a four-piece front buckle, a back and shoulder buckle, a cap ornament, chains, a curtle ax, and a spear. Janet gained great publicity for her work, but it occupied a considerable amount of her time, as her husband noted:

> [She] is giving most of her time to making jewelry, being just now engaged upon quite an order for Miss Maude Adams. [She] . . . is making all the jewels that . . . Adams wears and also a spear and a hunting knife. The last two articles are rapidly driving her to distraction on account of their size.[28]

In 1912, probably as the result of her apparently unstable marriage, Janet Payne Bowles returned, without her husband, to live with her children in Indianapolis. In September, Janet took a position as instructor in metalwork and jewelry at Shortridge High School, a post she would hold for the next thirty years.

———————————

Janet Payne Bowles returned to a city that had seen considerable continued activity in the Arts and Crafts movement since her departure seventeen years earlier. As early as 1898, a large arts and crafts exhibition organized by the Citizens' Education Society was held at the high school building. It was an "exhibition of the democratic art — the art of utility, domestic art, art in the utensils of life."[29] In addition to paintings by Indiana artists, there were exhibits of designs and illustrations, pottery and other ceramics, tiles, terra cotta, ornamental wrought iron, wood carvings, embroideries, stained glass, and leather work. Students from local grade and high schools as well as established artists were invited to display their best work. The exhibition was such a success that a second one was held the following year (see Fig. 5). A local newspaper carried a description of the latter:

> Embracing . . . the blending of the purely artistic and the mechanical, the product of the machine and the hand . . . [it] presents to the public a forceful illustration of the value of educating the mind and hand to work in perfect unison. Everything in this exhibit reveals the result of thought. The first and supreme essential to a product of art is the free exercise of the mind in order to conceive objects of beauty.[30]

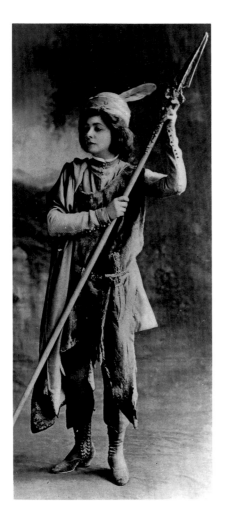

Fig. 4. Maude Adams as Rosalind in *As You Like It*, 1910. From *The Theatre* (July 1910).

A number of artists in Indianapolis who were represented at both the 1898 and 1899 exhibitions were instructors at the John Herron Art School (part of the John Herron Art Institute). The school was established in January 1902 by the Art Association of Indianapolis. Brandt Steele, one of the first instructors there, offered a class from 1902 to 1909 in design called "Modern Ornament—the study of nature and its application to design." Other faculty, some of whom were also art teachers at Shortridge High School, taught ceramic decoration, pottery, and industrial art and metalwork. Metalwork was offered as early as 1905. A year later the John Herron Art School introduced a course in hammered metalwork.

Many of the instructors also displayed their works at the annual exhibition of works by Indiana artists and craftsmen. These yearly exhibitions, held at the John Herron Art Institute (now the Indianapolis Museum of Art), included after 1911 a separate section called "Applied Arts," which meant jewelry and metalwork, textiles, leather, stained glass, pottery, ceramic decoration, wood carving, and book design. Most objects at these exhibitions were for sale. Janet Payne Bowles regularly displayed her jewelry and metalwork after her return to Indianapolis in 1912. Students and other art teachers at Shortridge High School also occasionally exhibited their work.

A number of other arts and crafts exhibitions, some of which traveled nationally, were held at the John Herron Art Institute and elsewhere in the city. In the early part of the century, exhibitions of art pottery at the museum displayed examples from the Rookwood, Teco, Grueby, Volkmar, Pewabic, Newcomb, Van Briggle, Hampshire, Marblehead, and Moravian manufactories. Various exhibitions and lectures were presented by organizations such as the Indiana Keramic Association, the American Federation of Arts, the Indiana Chapter of the Society of Western Artists, and the Handicraft Guild of Indiana.[31]

In 1905, a short-lived Arts and Crafts Society was organized and incorporated in Indianapolis. It ceased, however, by August of the following year. Based on the Society of Arts and Crafts in Boston, the purpose of the organization was "to establish a permanent exhibition of the products of handicraft, the work of local craftsmen to be exhibited, and also that of producers in other parts of the United States and Canada."[32] The society opened their organization in November 1905 with an exhibition of pottery, textiles, glass, metalwork, and other objects from various parts of the country, as well as from the Orient.[33]

A number of individuals were important in the proliferation of the Arts and Crafts aesthetic in Indianapolis. Roda Selleck (died 1924), a charter member of the Portfolio Club and Payne Bowles's former teacher, began Shortridge High School's art department in the early 1880s. The earliest classes, taught by Selleck, were drawing classes, including pencil, charcoal, and pen and ink. By 1898 she had gained recognition for being a pioneer in introducing "craftwork," such as leather, pottery, jewelry, and metalwork, in connection with the drawing course.[34] She was in charge of the pottery classes, and it was while under her direction that the pottery produced there from the late 1880s was known as "Selridge" ("Sel" for Selleck, and "Ridge" for Shortridge). It was often displayed, along with Selleck's own objects, at the annual exhibition of works by Indiana

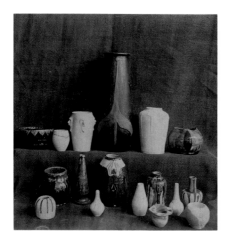

Fig. 5. Pottery by Brandt Steele displayed at *The Second Exhibition of Arts and Crafts*, High School Building, Indianapolis, April 14-22, 1899. Photo: Collection of Theodore L. Steele.

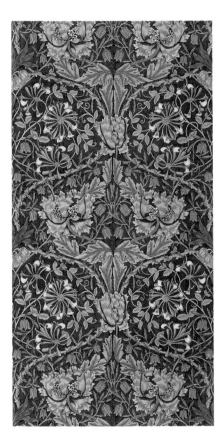

Fig. 6. William Morris, *Honeysuckle*, 1876, furnishing fabric; cotton plain weave, block printed. Indianapolis Museum of Art (acc. no. 20.11).

artists and craftsmen at the John Herron Art Institute, the Indianapolis Public Library, and elsewhere. It was also largely through Selleck's influence that Indiana was the first state to have a standardized art exhibition at the state fair.

Charity Dye (1849-1921), another teacher at Shortridge High School, also played an important role in the development of the Arts and Crafts movement in Indianapolis. In 1905, she started the William Morris Society at the high school as a supplement to her English classes. The main purpose of the society was the study of William Morris's life, art, and published works, and many of its activities were connected with the arts, including visits to exhibitions at the John Herron Art Institute and attendance at lectures at Shortridge High School and the museum on William Morris.[35] In 1907, Dye visited England, where she acquired from Morris and Company various textiles (see Fig. 6), tiles, wallpapers, printed matter (such as reproductions of a title page and of the first page of the Kelmscott Chaucer), reproductions showing stained glass, as well as tiles by William de Morgan.[36] Her various lectures included the exhibition of the objects she had purchased in London; she most likely also made these objects available to her students.

A third influential figure in the Arts and Crafts movement in Indianapolis was Wilhelmina Seegmiller (1866-1913), director of art instruction for the Indianapolis public schools from 1895 till her death.[37] She won international recognition as a leader in the development of art education for children. Through the art classes she organized in the public schools, Seegmiller raised the level of art instruction in Indianapolis on a par with that of other major cities in the United States. She initiated a stronger alliance between the John Herron Art Institute and the public schools, instituting weekly illustrated lectures and instruction in drawing and design for art teachers and advanced pupils. Like other art teachers in Indianapolis, Seegmiller was one of the early members of the Portfolio Club. She helped start a study collection of American pottery at Shortridge High School. The collection was comprised of objects from various American manufactories, including Rookwood, Van Briggle, Grueby, and Teco.[38]

In his short stay in Indianapolis, Frederic Allen Whiting (1873-1959), director of the John Herron Art Institute from June 1912 to May 1913, made his own contribution to the Arts and Crafts movement in Indiana.[39] Whiting was formerly the secretary of the Society of Arts and Crafts in Boston, where he had known the Bowleses, and he was probably instrumental in Janet's appointment to Shortridge High School. Whiting advocated the introduction of all kinds of craftwork at the museum, and toward this end he mounted an important exhibition in October 1912 of German decorative arts (see Fig. 7).[40] This exhibition traveled to Newark, St. Louis, Cincinnati, Pittsburgh, and Chicago. More than 1,300 objects—all types of graphics, wallpapers, textiles, ceramics, glass, metalwork, wood, leather, and ivory, as well as photographs—by such masters as Josef Hoffmann, Koloman Moser, Henry van de Velde, Peter Behrens, Richard Riemerschmid, and Joseph Olbrich presented a glimpse of contemporary German handicraft industries. At the time, the exhibition was one of the largest ever brought to the United States from a foreign country, and it was unquestionably the most important exhibition of decorative arts held in Indianapolis.

When Janet Payne Bowles was asked to teach art metal at Shortridge High School in the fall of 1912, she joined an active art department with an established curriculum. Lectures and demonstrations in art metal were first offered by Roda Selleck in the late 1890s. After the turn of the century, a wider variety of art courses was available at Shortridge, and students could also attend lectures presented by the staff of the John Herron Art Institute on the history of art and architecture. In 1909, the art department offered its first cabinetmaking class; by 1914, toy making and woodcarving were added; in 1921, Selleck taught a class in the history of art; and by 1929, commercial art courses were available. By 1935, 670 pupils were enrolled in art classes.

Early on, students in the art department had the opportunity to display their work at annual and semiannual exhibitions held at the school and elsewhere, including the John Herron Art Institute, the Indianapolis Public Library, the Carnegie Institute in Pittsburgh, the Indiana State Fair, and even London.[41] Often, the students competed with other high schools throughout the state, and prizes were sometimes awarded for the school's entire display.

In 1908, Harry Wood, then head of the art metal department at Shortridge High School, offered the first organized class in jewelry making in Indiana.[42] The classes became so popular that there was a waiting list. Students, who were first required to complete a year of drawing, were given instruction in toolmaking and in the handling of metals, such as coloration techniques. They made small, practical objects such as watch fobs, hat pins, necklaces, rings, and desk utensils. Guest speakers were also invited to lecture on various topics.[43]

By February 1913, Payne Bowles was able to offer an advanced course in art metal. She was so successful as a teacher that by spring 1914 there were forty-two students registered for class, as compared with sixteen in the winter session; and by September 1914, at least fifty students were enrolled in her classes.

Her classes were both educational and vocational. Many of her students simply took the class as an elective, but there were occasionally individuals who sought careers in metalsmithing. Initially most of the students were girls, who designed and made jewelry, but Payne Bowles later expanded the course to include boxes, carving sets, paper knives, and bill clips, thereby encouraging boys to take the classes. Eventually, the students were making swords, bayonets, hammered bowls, door knockers, bronze bells, and jewelry. Payne Bowles made available semi-precious stones and Florentine mosaics for the students to incorporate into their works.

The course was divided into three parts: design, construction (including mechanical processes and crafts), and art appreciation. Her pupils also studied the history and ethnology of metalwork, and especially that of the Egyptians, Phoenicians, and Greeks. Students created ten to fifteen projects per year, each year tackling progressively more complicated objects. Beginners designed and made simple rings and stickpins, as well as copper desk utensils; second-year students fabricated interlaced patterns for pendants with stone settings, among other pieces of jewelry; and in the third year, students learned to make spoons. By the fourth year, advanced students were working in gold and fashioning copper

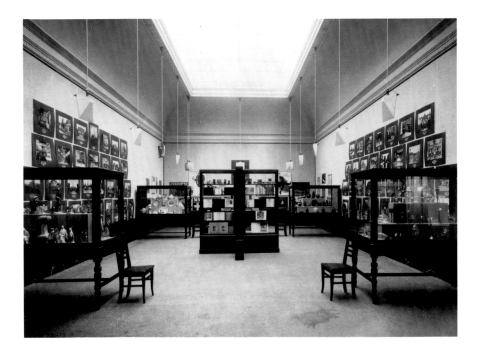

Fig. 7. View of the exhibition *German Applied Arts*, John Herron Art Institute, Indianapolis, October 1912. Photo: Bass Photo Co., Indiana Historical Society, Indianapolis, Indiana (neg. no. 31351).

objects on an anvil. In 1922, Payne Bowles instituted a metalwork class for students going onto dental college. This pre-dental course included practical instruction in filling teeth and soldering.[44]

Examples of the art metal students' work were on display at different times during the year at Shortridge. The students' work often reached professional standards, and curators and staff from the John Herron Art Institute regularly judged their work in the exhibitions. A number of Payne Bowles's students were fortunate enough to participate in exhibitions held yearly at Gorham in New York. A notice in the *Shortridge Daily Echo* for May 24, 1920, elaborated:

> *Shortridge talent is to be represented in five pieces of art metal work which are to be sent to R. L. Gorham of the New York firm, the exhibit to take place at the Fifth Avenue Art Gallery in June. An honor is paid to our institution because only six schools in the country have been asked to exhibit . . . : Pratt Institute, Columbia University, Peter Cooper Union, Rhode Island School of Design, Chicago Art Institute, and Shortridge High School.*[45]

In 1916, a group of students from Payne Bowles's classes in jewelry began meeting informally with her for discussions on art appreciation. Four years later, Payne Bowles officially founded the Art Appreciation Club at Shortridge High School.[46] Meetings were initially held alternately at the high school and the John Herron Art Institute. By 1922, there were forty members in the club, and by 1926 the club was transformed into a museum class and held most of its weekly meetings at the museum. That same year, members began to receive school credit for their attendance. By 1929, the club was registered with the State Federation of Art Clubs.

The program for the Art Appreciation Club included lectures by Payne Bowles, by club members, and by guest speakers on a wide variety of topics. Payne Bowles often lectured about the "cultivation of the powers of seeing," as well as about exhibitions held at the John Herron Art Institute and other locations in the city. One or more field trips were taken per semester to downtown Indianapolis in order "to see if beauty [was] developing in commercial life." Other club activities of a more general art-historical nature included visits to the John Herron Art Institute to view exhibitions, from American paintings to textiles and photographs.

In 1927, Payne Bowles founded the Workmanship Guild, another association of students in the art metal department. Members were selected by Payne Bowles on the basis of skill and honesty of purpose. The Guild's creed stated that "honesty in work is the true basis for honest character, enlightened mind, creative growth and personal happiness for the individual and civic purity for the community," and that its purpose was "to stimulate to life long endeavor the striving to be an honest, skilled, creative workman...."[47]

The death of Roda Selleck in 1924 left a sizeable gap in the ceramics curricula, and in 1929 Payne Bowles was asked to begin teaching the pottery classes (see Fig. 8). Although some advanced pupils used a wheel, most of the pottery was made by hand or by casting. Some clay pots were built by the coil method and shaped by templates made by students. Pupils made objects such as vases, teapots, bowls, figures, and copies of ancient Greek vessels. The students also created pitchers inspired by antique Roman pewter examples and pots decorated in the Chinese manner. Payne Bowles, who worked with her students at a single long table, gave demonstrations on the basics of pottery making and spoke about the principles of art. Pottery made by the students was often on view at the school and other locations.

According to various published sources, one of Payne Bowles's most important commissions was received during the early twenties from the Florentine art patron Signor J. Bossilini. Payne Bowles herself reported that she decided to "enter an international competition for a gold chalice for a church in Italy, a competition sponsored by J. Bossilini, famous Italian art patron."[48] Though it cannot be verified, Payne Bowles is reported to have won the first prize and was asked by Bossilini to make a chalice for every Catholic church in Italy. "I had enough orders to last the rest of my life. But of course the war stopped that. I do have 12 in churches in Italy now, however."[49] These supposedly included a chalice made about 1926 for Santa Annunziata in Florence and another made for Saint Peter's in Rome, but neither the objects nor substantiating documentary evidence now exist to support this claim.[50]

Several other objects for this commission are mentioned in various publications, but once again the whereabouts of the objects themselves are unknown.[51] One other piece of "evidence" exists: a photograph of a copper ewer by Payne Bowles, now in the collection of the Indianapolis Museum of Art and slightly altered from its appearance in the photograph (see Braznell essay, Fig. 18), is annotated by Payne Bowles, "Bossilini ewer—$1,000 prize."[52]

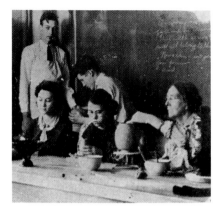

Payne Bowles also began to travel in the 1920s and her destinations included the United States, South America, and western and eastern Europe. Her many domestic trips afforded her the opportunity to view the art collections of various museums, attend classes, and present lectures.[53] In Paris, she visited the well-known *Exposition Internationale des Arts Décoratifs et Industriels Modernes*, the seminal exhibition of works in the Art Deco style.[54] Payne Bowles spent the summer of 1925 in Paris and Switzerland with her daughter. In Geneva, she studied with metalsmiths at the university.[55] She spent time in Florence during the summer of 1926, where she attended a lecture by the renowned art historian Bernard Berenson. She was able to observe firsthand early metalwork by such masters as Benvenuto Cellini, and she absorbed the lessons of Michelangelo and Donatello.[56] In the summer of 1933, Payne Bowles journeyed to South America, where she studied the Incan and Mayan civilizations.[57]

In the summer of 1927, Payne Bowles made her first visit to Russia. She traveled to Moscow for a four-day tour, where she viewed a distinguished collection of Russian goldsmiths' work.[58] In 1928, Payne Bowles was asked to join a group of distinguished American educators on a trip to Russia to observe the Russian education system. The trip was arranged under the auspices of the American Society for Cultural Relations with Russia, of which John Dewey was a prominent member. Her stops included Finland, Leningrad, and Moscow, as well as Sebastapol, Yalta, and Kiev.[59] Payne Bowles shared her experiences and impressions of her travels through numerous lectures to the various Indianapolis art clubs.

Payne Bowles remained an active member of the Portfolio Club and regularly served as vice-president. During the 1920s, she lectured frequently on various art-related topics as well as on her personal views. Her last presentation, in January 1939 to the Portfolio Club, was entitled "The Step-Off" and revealed her thoughts about life after death. Payne Bowles was active in the Unitarian Church and community activities and belonged to such organizations as the Woman's Poetry Club and the Woman's Rotary Club.

Payne Bowles retired from teaching due to ill health in June 1942. That year, her daughter returned from New York City to Indianapolis to care for her ailing mother. When Janet died on July 18, 1948, her son and daughter inherited the bulk of her estate, including over 120 pieces of metalwork. In 1968 they presented these objects to the John Herron Art Institute, now called the Indianapolis Museum of Art.

Janet Payne Bowles lived and worked according to the precepts of the English Arts and Crafts theories established by William Morris. She took up the Arts and Crafts "cause" with determination; her jewelry and metalwork were handcrafted, showed a "truth to material," and gave her great pleasure. There is an inherent spirituality to her metalwork. Part of a tightly interconnected local arts network, she also had a national impact as a designer, artisan, and educator. She and other individuals actively contributed to Indianapolis's participation in the Arts and Crafts movement and to important advances in American Arts and Crafts ideology, aesthetics, and philosophy.

Fig. 8. Art pottery class at Shortridge High School, ca. 1934. Janet Payne Bowles is at far right. From the *Shortridge Daily Echo* (Jan. 26, 1934). Photo: Indiana Historical Society, Indianapolis, Indiana (neg. no. C4830).

Notes

The author is grateful to Martin Krause and W. Scott Braznell for calling some of these references to his attention.

1. See the advertisement in the catalogue of the Art Association (Indianapolis), *Collection of American Paintings* (Indianapolis, 1888).

2. See *Indianapolis Star*, Apr. 25, 1954, pp. 23-27.

3. The Portfolio Club, *Constitution, Officers, Committees, Members and Scheme of Exercises, 1890-91*, archives of the Portfolio Club, Indianapolis.

4. See Warkel, n.p.; and Kaplan, p. 287, no. 151.

5. Thompson, p. 55.

6. According to Brandt Steele, in a paper entitled "An Interview with James McNeill Whistler" (Brandt Steele Papers, Indianapolis), Bowles's inspiration to create *Modern Art* was his discussions at the Portfolio Club and "a book brought to the club . . . written and printed by William Morris. At Chicago [in 1892] Joe [Bowles] saw a collection . . . of original gothic manuscripts together with some books printed at the Kelmscott Press in England under the direction of Morris; Soon after the first number of [*Modern Art*] was off the press, Bowles was again in Chicago . . . spending many hours with the collection of books. . . . Back here in Indianapolis, his four friends, Mr. Darnebee of the Hollenbeck Press, Mr. Hollenbeck himself, Bruce Rogers and above all Carl Lieber, gave him the encouragement that he most needed. . . ." For more on Bowles and Rogers, see Thompson, pp. 55-67; Finlay, pp. 30-33, 102; and Bowles 1894, n.p.

7. Stewart, p. 14; and *Shortridge Daily Echo* (hereafter *SDE*), June 18, 1942, pp. 1, 3.

8. Buschmann, p. 18.

9. Stewart, p. 14. See also Brenton, p. 7; and Kohlman 1924, p. 56.

10. Buschmann, p. 18.

11. Boston 1897, p. 18; Bowles 1897, pp. 17-20.

12. New Jersey State Census, 1905, New York Public Library.

13. See Kelley, pp. 29-51; and Harris, pp. 93-95, 97-98, 119. I am grateful to Peggy Ann Brown for bringing to my attention the citation in Kelley and other information concerning Helicon Hall.

14. For more on Helicon Hall, see the essay by Darling in this catalogue. See also Kelley, pp. 29-51.

15. Upton Sinclair, quoted in *New York Times*, Oct. 7, 1906, part 3, p. 2.

16. Schorer, p. 113.

17. *New York Times*, Mar. 17, 1907, part 2, p. 1; Mar. 18, 1907, p. 16; and Mar. 22, 1907, p. 3.

18. See letter from J.M. Bowles to F.A. Whiting, March 22, 1910, in the archives of the Boston Society of Arts and Crafts, Boston Public Library. I am grateful to Evelyn Lannon of the Boston Public Library for help with the Whiting papers.

19. *SDE*, Oct. 25, 1922, p. 4; *Indiana Daily Times*, Nov. 29, 1920, p. 9. See also New York, The Metropolitan Museum of Art, p. 99. I am grateful to Stuart W. Phyrr, curator of arms and armor at the Metropolitan, for providing the latter citation.

20. Stewart, p. 14; Kohlman 1924, p. 55; *Indiana Daily Times*, Nov. 29, 1920, p. 9; and Buschmann, p. 18.

21. The purchases included a cross, similar to the one she wore at their first meeting, a silver and gold reliquary, two silver and gold incense burners, and several rings and spoons. A photograph of these objects is in the Janet Payne Bowles Archives of the Indianapolis Museum of Art and is annotated in Payne Bowles's hand on the reverse: "Purchased by Sir Casper [*sic*] Purdon Clarke."

22. There is no documentary evidence for these commissions, which W. Scott Braznell calls "fantasy commissions": see his essay in this catalogue for more on her work for Morgan.

23. Kohlman 1924, p. 54.

24. *Indiana Daily Times*, Nov. 29, 1920, p. 9.

25. See Kohlman 1924, p. 56: "Her jewelry was invited for exhibition with the work of a group of craftsmen and won the Spencer Trask prize. Mr. Trask then became her first patron." No other documentation for this prize has been found, nor is it known whether Payne Bowles actually completed commissions for Trask.

26. No copy of the catalogue for this exhibition has been found, so Payne Bowles's participation has not been substantiated. For a review of the exhibition, see "National Society of Craftsmen Exhibition," pp. XCVII-XCVIII; and Lamb, pp. 95-97.

27. For a discussion of this exhibition, see "Town & Country Calendar: Art Notes," *Town & Country* 64 (Dec. 24, 1910), p. 8; Fosdick, "The Fourth Annual...," p. LXXXI; and "Fourth Annual Exhibition...," *Jewelers' Circular Weekly* 61 (Dec. 21, 1910), p. 63.

28. Letter from J. M. Bowles to F. A. Whiting, March 22, 1910; see note 18.

29. Indianapolis, Indianapolis High School, *First Exhibition....* See also *Indianapolis News*, Apr. 14, 1898, p. 5; Apr. 15, 1898, p. 10.

30. R.B. Gruelle, "Exhibit of Arts and Crafts," *Indianapolis News*, Apr. 17, 1899, p. 9. For reviews, see *Indianapolis News*, Apr. 19, 1899, p. 7; and Seegmiller, pp. 213-21.

31. For specifics on these exhibitions and lectures, see *Indianapolis News*, Nov. 24, 1903, p. 2; Feb. 20, 1915, p. 12; Apr. 18, 1914, p. 5; and Kohlman 1915, p. 7.

32. See *SDE*, Nov. 22, 1905, p. 1.

33. See "Exhibitions Past and To Come," *Brush and Pencil*, 17 (Mar. 1906), p. 63. See also Taylor, "The Arts and Crafts Society...."

34. See *SDE*, Dec. 11, 1907, p. 1; and Nov. 17, 1924, p. 1.

35. *SDE*, Jan. 22, 1906, p. 1; Mar. 12, 1906, p. 1; Feb. 18, 1907, p. 1; and Mar. 20, 1908, p. 1.

36. *Indianapolis News*, June 11, 1921, p. 10. In 1920 Charity Dye donated these objects to the John Herron Art Institute (acc. nos. 20.79-20.118). See also P. S. Gilfoy, *Fabrics in Celebration from the Collection*, exh. cat., Indianapolis Museum of Art (Indianapolis, 1983), pp. 208-09, no. 134.

37. See Burnet, pp. 257-67.

38. *SDE*, Feb. 28, 1910, p. 4.

39. In 1913, Whiting left Indianapolis to become director of the Cleveland Museum of Art. See Robertson.

40. This exhibition was assembled by the Deutsches Museum für Kunst in Handel und Gewerbe, Hagen in Westphalia, and was organized by the Newark (N.J.) Museum Association. See *Indianapolis Star*, Sept. 22, 1912, p. 43; Sept. 29, 1912, p. 13; Oct. 2, 1912, p. 5; and *Indianapolis News*, Oct. 2, 1912, p. 4; Oct. 25, 1912, p. 9.

41. See *SDE*, Mar. 2, 1908, p. 1; and Apr. 13, 1908, p. 1.

42. *SDE*, Oct. 6, 1910, p. 1; and Apr. 11, 1912, p. 1.

43. *SDE*, Oct. 25, 1909, p. 1; Nov. 9, 1909, p. 1; and Nov. 7, 1934, p. 1.

44. See *SDE*, May 12, 1922, p. 1; Apr. 13, 1933, p. 1; and Mar. 26, 1924, p. 4.

45. *SDE*, May 24, 1920, pp. 1-2, 4. For more on participation in the Gorham exhibition, see *SDE*, May 31, 1920, p. 1; June 3, 1921, p. 1; and May 25, 1923, p. 4.

46. See *SDE*, Jan. 20, 1920, p. 1. In 1923, classes in art appreciation for general students became part of the curriculum; see *SDE*, May 21, 1923, p. 1; and May 27, 1925, p. 1.

47. *SDE*, May 17, 1927, pp. 1, 3.

48. See Stewart, p. 14; *SDE*, July 23, 1948, p. 3; Kohlman 1924; and B. Hendricks, "Notes About Art and Artists," *Indianapolis News*, July 23, 1921, p. 3.

49. See Brenton, p. 7.

50. *SDE*, Sept. 15, 1926, p. 1; and Arthur Ellis, transcript of Janet Payne Bowles oral history session, Indianapolis Museum of Art, April 24, 1991, p. 16. Ellis was a student in Payne Bowles's jewelry classes from 1931 to 1936.

51. See Kohlman 1924, p. 56; *SDE*, Mar. 8, 1927, p. 4; Sept. 26, 1927, p. 1; *Indianapolis Star*, Jan. 5, 1930, p. 39; Buschmann, p. 18; and Indianapolis, John Herron Art Institute, *Catalogue of the Twentieth Annual . . .* (1927), no. 187.

52. The photograph is in the Janet Payne Bowles Archives at the Indianapolis Museum of Art.

53. See *SDE*, Apr. 26, 1922, p. 4; May 25, 1923, p. 4; Jan. 8, 1924, p. 1, and May 26, 1924, p. 1.

54. *SDE*, Sept. 17, 1925, p. 1.

55. *Ibid.*

56. *SDE*, Sept. 15, 1926, p. 1.

57. *SDE*, Sept. 13, 1933, pp. 1, 4.

58. *SDE*, Sept. 26, 1927, pp. 1, 4.

59. See *SDE*, Sept. 21, 1928, pp. 1, 4; Sept. 24, 1928, p. 1. See also "American Educators in Russia," p. 779; and Dykhuizen, pp. 235-39.

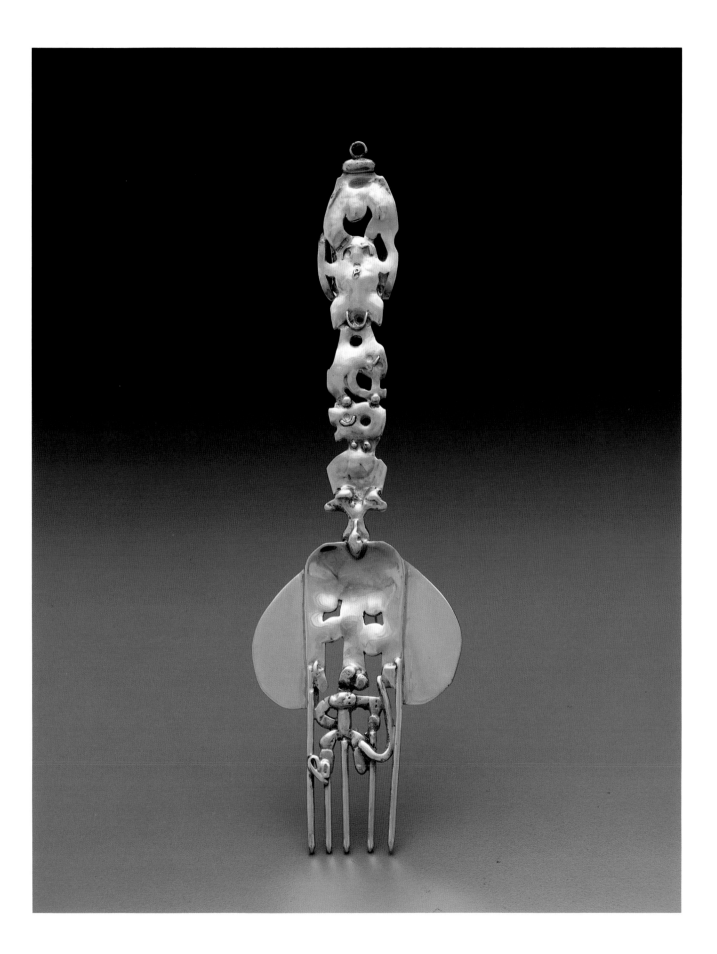

From "New Woman" to Metalsmith: A Voyage of Self Discovery

by Sharon S. Darling

Connoisseurs associate the name of Janet Payne Bowles with a collection of unique Arts and Crafts metalwork owned by the Indianapolis Museum of Art; former pupils recall her as a dedicated and inspiring teacher. A closer look reveals a complex figure, a woman of strong character whose life was as intriguing and unconventional as her metalwork. Indeed, both her personal life and professional development are worth examining for what they reveal about the role of women in the Arts and Crafts movement and the emergence of feminist identity in the early years of the twentieth century.

In its efforts to place the applied arts on a par with the fine arts, the Arts and Crafts movement made metalworking, weaving, pottery making, embroidery, and other handicrafts fashionable pastimes. While most of the women practitioners of these crafts remained hobbyists, an impressive number became professionals who depended on the sale of handmade jewelry and metalwork for their livelihood. Many women worked as designers, creating sketches for jewelry and metalwork which were then executed by men; a few, however, executed their own designs following pure Arts and Crafts principles.

Given the movement's emphasis on the home and the dignity of manual labor, it seemed quite natural for women to seek advancement through careers associated with the creation of home furnishings. Work in the crafts was particularly appealing to intelligent and artistic middle-class women who needed to work outside the home to support themselves yet were limited by education or social mores to routine, low-paying jobs such as typist, switchboard operator, or department store clerk. It seems that nearly all of the women metalsmiths were single—unmarried, widowed, or divorced—and middle-class, forced by circumstances to earn a livelihood.

Metalworking offered the creative and physical challenges of a traditionally "masculine" entrepreneurial profession while allowing women metalsmiths to remain "feminine" because their talents were applied to the creation of household objects or jewelry. Jewelry making required only a small investment in tools, equipment, and precious metal. Nor did it demand the muscles or perseverance required to hammer and shape large items like water pitchers, vases, or lamp bases. Handwrought jewelry and metalwork expressed individuality as well as

Plate 3. *Fork*, ca. 1925-29 (cat. 106)

made a social statement, since these objects were tangible evidence of a commitment to Arts and Crafts ideals. To some metalworkers, the bold designs were the ultimate symbols of modernity; to others, the obviously handmade objects reflected a return to pre-industrial values, the triumph of man over machine. In many ways, this dichotomy in the revival of the crafts can be viewed as a reflection of the tensions experienced by men and women as Victorian thought and standards of behavior were challenged by new interpretations at the turn of the century.

Many women became teachers in the manual arts programs instituted in the 1880s by numerous public secondary schools and private industrial training schools. Jewelry making, art pottery, woodworking, and other crafts were an important part of the curriculum in art schools and the focus of classes sponsored by progressive art museums. By the end of the century, for example, degrees in decorative design were offered by the School of the Art Institute of Chicago. Its graduates, the majority of whom were female, went on to become teachers and shop owners as well as designers for large firms.

Jewelry and metalwork designed and executed by women figured prominently in the exhibitions sponsored by arts and crafts societies and museum or international fairs like the Panama-Pacific International Exposition of 1915. Many of the artworkers gained national recognition through the publicity generated by magazine and newspaper articles; others garnered prizes and monetary awards.

Many of the best-known female metalsmiths entered their work in the annual applied art exhibitions held in Boston, Chicago, Detroit, Minneapolis, and Cleveland. Among those achieving enviable reputations in the Boston area were Elizabeth E. Copeland, Mary C. Knight, Josephine Hartwell Shaw, and Madeline Yale Wynne. In Chicago, Clara Barck Welles founded the successful Kalo Shop, while Jessie M. Preston, Clemencia Cosio, Christa M. Reade, Wilhemina Coultas, Jennette Pratt, and Leonide C. Lavaron operated studios in the Fine Arts Building.[1] In New York, Florence D. Koehler and Marie Zimmermann were well-known arts and crafts jewelers. Meanwhile, a group of artists that included Mary Blakeslee, Jane Carson, Mildred G. Watkins, Ruth Smedley, and Mary Barnum was active in Cleveland.

It was not uncommon for female metalsmiths to be equally talented in other branches of the crafts or as writers. Often they worked as teachers, providing instruction in their studios to females young and old. In Chicago it was fashionable for society women to take jewelry and painting lessons from Madeline Yale Wynne, whose studio in the Fine Arts Building also served as a weekly meeting place for the literary society known as The Little Room.[2] Florence Koehler taught china painting in the 1890s to the female members of Chicago's exclusive Atlan Ceramic Art Club before going on to pursue a career as a jeweler and painter in New York.

Chicago metalsmith Clara Barck Welles (1868-1965) was among the most successful of these teacher/entrepreneurs. Like Payne Bowles, Welles did not pursue a career in the crafts until midlife: in fact, she did not enter art school until she was thirty. In September 1900, following her graduation from the School

of the Art Institute of Chicago with a degree in decorative design, Welles opened the Kalo Shop, adapting the Greek word for beautiful as the name for her new venture. Welles and her young female assistants, known as the Kalo girls, at first specialized in burnt-leather goods, graphic design, and even some weaving. When in 1905 she married George S. Welles, a coal dealer and amateur metalworker, he encouraged her interest in jewelry and metalwork.

Clara Barck Welles set up a workshop in a shed behind the couple's residence in suburban Park Ridge, Illinois. In the rambling Queen Anne house, surrounded by large vegetable and flower gardens, she organized the Kalo Art-Craft Community, where young female students practiced jewelry design and fabrication in her "school in a workshop." The initial workforce consisted of Welles, who served as designer; a silversmith; and the female apprentices, who executed simple silver and gold jewelry set with semiprecious stones, as well as desk accessories wrought in copper or brass. Welles soon hired several Scandinavian silversmiths to execute her designs for hollowware and flatware.

The Kalo Shop operated in Park Ridge until 1914, when, following divorce from her husband, Welles consolidated the shop with its Chicago salesroom. Long after other arts and crafts shops had closed or become retail outlets, the Kalo Shop continued to produce its unique line of handwrought silver. When Welles retired in 1959, she gave the shop to her employees, who continued to work until the last silversmith died in 1970. When it closed, Clara Welles's classic designs were still being sold, epitomizing the Kalo motto of "Beautiful, Useful, and Enduring."[3]

During the Progressive era between 1890 and 1920, educational and vocational opportunities for women expanded dramatically. At the same time, traditional attitudes and values regarding female intelligence, political and economic equality, sexuality, and dress were challenged by a generation of what were known as "New Women," who paved the way for women in the workplace. Often college educated, these women asserted themselves boldly in traditional fields like architecture and medicine and pioneered new occupations in social work, industrial health, and home economics. Like suffragist/temperance advocate Frances Willard or social reformer Jane Addams, many did not marry, but committed their lives to reforms they hoped would lead to a just and democratic society. But, like their married sisters, they conducted their self-improvement campaigns for women and society within the traditionalist notion of a woman-tended home. In contrast, the New Woman who came of age after 1900 was more radical in her quest for social, economic, and political reform. Members of this second generation were often bohemian in dress and deed, as well as controversial in their advocacy of birth control and sexual freedom.[4]

Separated in age by only four years, Clara Welles and Janet Payne Bowles were clearly members of the first generation of progressive New Women. Both were drawn to the more traditional study of graphic design before turning to jewelry and metalwork. Although Welles was childless, both she and Payne Bowles accepted the traditional loyalties and beliefs associated with marriage. Both married creative but chemically dependent men: George Welles became an

alcoholic; Joseph Bowles was described as a drug addict. Each took the initiative to end an unhappy marriage and went on to pursue in earnest her work as a metalsmith. Determined to make their mark in a competitive man's world, they sought economic independence and creative fulfillment on their own terms rather than relying on the support or reputations of their husbands.

Employing as many as fifty silversmiths, Welles never executed the hollowware and flatware that she designed for her shop's large clientele. On the other hand, working alone, Payne Bowles designed and executed her silverwork from start to finish, completing one commission at a time. The work of each woman was exhibited and praised during her lifetime, but had become passé by the time of her death. Today their metalwork is studied for the beauty of its design and execution; but it also symbolizes one of the effects of the revival of the handicrafts in combination with the evolution of the New Woman on the world of work.

In 1895, when Janet Payne married Joseph Bowles (see Fig. 9), there were few indications that the traditional young homemaker would become a nationally recognized art metalworker and educator. Her transformation occurred over a period of twenty years and in four distinct phases. In the first phase, between 1895 and 1902, the married but childless Janet exemplified the restlessness of the New Woman, searching for her identity and exploring her potential as a creative person. In the second phase, beginning with the birth of their first child in 1902, Janet and her husband attempted to live according to the principles of the Arts and Crafts movement, integrating art into their daily lives and experimenting with cooperative housekeeping arrangements. When this experiment ended in the flames of Helicon Hall in 1907, Janet's life entered a third phase, when she stopped being a dilettante and became a working metalsmith increasingly responsible for the support of her family. By 1912, when she began to teach at Indianapolis's Shortridge High School, she had become a mature New Woman: she was pursuing meaningful work and enjoying economic self-sufficiency.

That Janet did not follow the example of other young women of her class — namely, to devote herself to the role of wife and homemaker — can be attributed to a number of circumstances, but above all to her unswerving intellectual curiosity. Lacking a college education, she would undertake her own enlightenment, eagerly pursuing intellectual gratification by reading and attending lectures. She was helped in this following the Bowles's marriage, when the young couple immediately moved to Boston, then the intellectual and cultural hub of the country. Here she joined her husband in playing an active role in the artistic community.

Boston: An Artistic Awakening

Joseph Bowles's connections through his magazine *Modern Art* undoubtedly helped propel the couple into an avant-garde circle. It was a time of intellectual ferment. While some debated the implications of Darwin's theory of evolution on religion, others followed the lectures on the "New Psychology" by William James of Harvard University, while artists and architects disseminated the ideas of

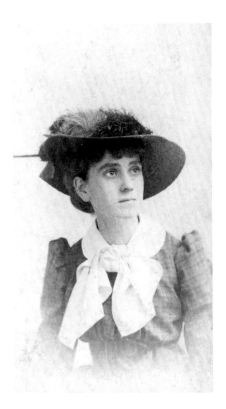

Fig. 9. Janet Payne Bowles, ca. 1890s. Photo: Indianapolis Museum of Art.

William Morris. Joseph and Janet Bowles, who in Indianapolis had been among Morris's first American disciples, were readily welcomed as members of Boston's artistic community.

Janet Payne Bowles was soon immersed in writing book reviews for *Modern Art* and painting Celtic-inspired borders on the pages of *The Second Epistle of John* (see Pl. 2), which Joseph printed by hand in the manner of Morris's Kelmscott Press. As ardent participants in the handicraft revival, Joseph and Janet Bowles witnessed the birth of the Boston Society of Arts and Crafts—the first of its kind in America—in 1897 and submitted book illuminations to the society's exhibition in 1899.

Always curious, Janet sought to develop herself mentally and emotionally. From an inscription made in 1900 in the flyleaf of a copy of Plato's *Republic*, we know that this work, Browning's *Complete Poems*, and James's *Principles of Psychology* were her "three most precious books."[5] She audited the classes taught by James, whose ideas she would embrace for the rest of her life. A distinguished teacher whose public lectures in philosophy drew large crowds, James popularized the new field of empirically based psychology, expounding his theories regarding the formation of habits, the influence of ideas and beliefs on conduct and the nervous system, and the psychological need for religious faith of some kind.

James's theories of pragmatism fascinated the introspective Payne Bowles, who had turned to writing as a vehicle of self-expression as well as a socially acceptable source of supplementary income. However, neither study nor writing provided the total spiritual immersion she sought in her quest for creative fulfillment. Instead, Janet's introduction to such all-consuming work would take place in the rundown workshop of a Russian metalworker on Boston's waterfront, rather than in a classroom.

Janet set up a small studio in her apartment, where she executed book illuminations and jewelry. She may even have taken lessons from one of the many Boston craftsworkers, since working in metal, and jewelry making in particular, was becoming a popular hobby. And she continued to seek entry into the masculine world of professional metalworking.

In eccentricity of design and workmanship, Payne Bowles's metalwork most closely resembled that of Madeline Yale Wynne (1847-1918), whose handmade jewelry was featured in arts and crafts exhibitions in Boston and Chicago.[6] Wynne also was self-taught, but with the advantage of having been encouraged to experiment in her childhood.[7] A writer, painter, and woodworker, as well as a metalsmith, the energetic Wynne was a founding member of the arts and crafts societies in Boston, Chicago, and Deerfield, Massachusetts. Dividing her time between homes and studios in Deerfield and Chicago, where she spent six months each year between 1893 and 1904, she taught classes in jewelry and silversmithing as well as leatherworking, embroidery, and painting. In Chicago, Wynne, who was either widowed or divorced, kept house for her bachelor brother and taught metalworking. He shared her talent and turned out handsome silverwork in his home workshop.

Although much younger, and considerably less wealthy than Wynne, Payne Bowles would have seen Wynne's work on display at the Boston Arts and Crafts Society's exhibitions and may have known her personally. And like Wynne, she viewed her metalwork as creative relief from domestic duties. But Payne Bowles's Boston experiences had introduced her to new philosophies of art and politics and awakened her intellectually.

Living with Art and Nature

In 1902, Joseph Bowles was named manager of the art department at *McClure's Magazine* and the family moved to Rye, a suburban community outside New York City. In July, at the age of thirty, Janet Payne Bowles gave birth to her first child. Janet was considerably older than most first-time mothers in her day, but it is not known if she had difficulty conceiving or if the "modern" couple was reluctant to do so for emotional or financial reasons. Janet named her daughter Mira after one of the largest and brightest stars in the sky. The vastness of the universe and the mystery of its star—manifestations of the "spiritualism" of nature—were recurring themes in Janet's writing and in her personal philosophy.

Payne Bowles embraced motherhood and writing with energy and creativity, taking advantage of the opportunity to experiment with personal interpretations of psychology, nature, and art. These she combined in her article on "Artistic Dress for Children," published in Gustav Stickley's influential Arts and Crafts periodical, *The Craftsman*, just a few months before the birth of her son, Jan, in 1904. Stressing the educational and creative aspects of children's attire, Payne Bowles pointed out that children, like actors, should be colorfully and appropriately dressed for the kind of play that filled their time. Children's dress served as a practical form of art education, providing daily opportunity to integrate art into the life of one's child.

Like other proponents of dress reform, Payne Bowles advocated freedom in children's dress with a strong concern for health. Such "progressive" parents dressed their children in washable, sturdy play clothes like rompers, smocks, and bloomer and tunic combinations called Russian suits.[8] In photographs taken of Mira in 1905, at age three, she is wearing a cotton Russian suit and a large bow in her hair.

Payne Bowles soon completed *Gossamer to Steel*, a "psychical" novel which she sent for comment to her mentor, William James. "I could not go to bed until I had finished a ms. which had gripped me with its dramatic psychology and heavenly beauty," James wrote after reading the manuscript, undoubtedly encouraging its acceptance for publication by Doubleday-Page.[9]

Described as "the story of a girl's soul," *Gossamer to Steel* is the melodramatic tale of a beautiful and idealistic seventeen-year-old secretary who looks to the stars for guidance but is driven to murder as a result of guilt. Despite stilted prose, the novel is filled with sexual tension. The innocent young heroine seeks knowledge and practical experience in a business career, only to be abused and controlled by men driven by physical, political, paternalistic, or philosophical

needs. The heroine's actions are distrusted and misinterpreted by all three of the women with whom she seeks the bond of sisterhood. But in the end, the purity of her "soul" and marriage triumph.

Did Payne Bowles admire or mock her heroine? Can one afford to be ruled by emotion rather than reason? Unfortunately, the novel's main characters are too shallow to lead to any conclusive answers regarding Payne Bowles's motivation. But the novel is useful in bringing to light issues that Payne Bowles considered important at the time: the philosophical debate about reality versus perception; the dilemma of individual growth versus duty to husband; and the lure of sexual attraction versus the desire for social respectability.

Despite its limitations, the novel reveals how important the search for "truth" and its impact on human behavior was to Payne Bowles's emotional well-being. These were clearly years of soul-searching and internal debate. The book also acknowledges her familiarity with the doctrine of socialism then widely proposed by many in her social circle as an alternative political system. One wonders, did Payne Bowles have an affair with the anarchist metalworker in Boston or was he only attractive to her as a mentor? Did she feel that she was being stifled by the limitations of marriage, housekeeping, and middle-class morality? One can assume that she did, given her willingness to live in artistic communities whose residents attempted to set new standards for art and behavior despite ridicule from the mainstream of late Victorian society.

By the time the manuscript for *Gossamer to Steel* was returned to Payne Bowles for final corrections, the family was living in the utopian Home Colony established by the writer Upton Sinclair at Helicon Hall on the outskirts of Englewood, New Jersey (see Fig. 10). Some forty adults, with fourteen children, had responded to Sinclair's invitation to purchase stock in the Home Colony, which was headquartered in a rambling, stately building that housed many luxurious appointments, including a swimming pool, a bowling alley, and a theater. Though each family occupied separate apartments, they ate in a communal dining room and shared common living areas.

An experiment in socialized domestic living, Helicon Hall put into practice the theories set forth by the radical feminist Charlotte Perkins Gilman. In her influential books, *Women and Economics* (1898) and *The Home: Its Sphere and Influence* (1903), Gilman praised apartment hotels, where families could live in private suites connected to central kitchens, dining rooms, laundries and nurseries. She proposed "family clubs" with communal kitchens and cooperative nurseries to lessen the emotional and financial hardships imposed on young families, and especially women, by housekeeping and child care. Above all, this arrangement would permit women to combine jobs and motherhood, thus increasing the economic independence that was essential for true equality between men and women.[10]

Gilman's controversial ideas particularly appealed to artists and intellectuals who wished to escape the monotony of domestic duties as well as the cramped apartments and high rents that accompanied city living. The *New York Times* pointed out at the time:

Mr. Sinclair thinks there are enough authors, artists, and musicians, editors and teachers and professional men handicapped by the miseries of the domestic station, and duly converted by Mrs. Charlotte Perkins Gilman to co-operate practically in the establishment of a "home colony" within an hour's ride of New York.[11]

Janet and Joseph Bowles fit neatly into the above description when they moved to Helicon Hall with four-year-old Mira and two-year-old Jan upon its opening in November 1906 (see Fig. 11). The cooperative child care and housekeeping arrangements undoubtedly appealed to the couple, reducing domestic stress for Joseph and freeing Janet to work on her novel. Janet and her children could also wear without comment the comfortable artistic clothing favored by arts and crafts practitioners, who preached utility, simplicity, and beauty in all aspects of life. Janet may have been among the many women residents who wore bloomers, the calf-length divided skirts worn for bicycling and country outings, but considered too scandalous to wear on the streets of Englewood.[12]

The country setting was both elegant and idyllic. One resident recalled: "At Helicon Hall the windows of your room looked out upon lawns and big trees and flower gardens; and the door opened upon a gallery that hung above a tropical garden.[13] Housing forty avant-garde individuals, Helicon Hall was also the setting for stimulating conversation:

When you came home at night, instead of sitting down to a grumpy boarding-house table surrounded by the usual boardinghouse types, you ate your dinner seated between a Socialist and a Single Tax man, the one perhaps a college professor, the other a carpenter, or perhaps at the elbow of an aspiring young writer, or beside an artist who was getting ready to startle the world.[14]

This controversial group was regularly supplemented by guests, among them Charlotte Perkins Gilman and anarchist Emma Goldman. William James and the educator John Dewey were occasionally guests, as well.

The children at Helicon Hall ranged in age from one to twelve and had their own dining room, playroom, and nursery. One full-time employee was in charge of the children, assisted by mothers who rotated four-hour shifts. The children played in the woods, took "air-baths" in the sunshine, and enjoyed freedoms unusual for the day.[15] Janet spent considerable time playing with her children, and insisted that Mira and Jan sleep in their parents' room rather than in the nursery.

Janet's nurturing instinct probably saved her children from possible death when, after only five months of residence, a firestorm destroyed Helicon Hall in the early morning of March 16, 1907. There were differing opinions as to the cause of the fire: some believed that a gas leak caused a single massive explosion. An article in the *Indianapolis News* gave an account of the Bowleses' harrowing escape as they jumped from their sleeping quarters into the snowdrifts below. Each of them was badly burned,[16] and the family lost everything, including Janet's manuscript.

Fig. 10. View of the south end of the atrium at Helicon Hall, ca. 1907. Photo: Lilly Library, Indiana University, Bloomington, Indiana.

New York: Years of Transition

Moving into the town of Englewood, Joseph continued to work as an editor in New York City. Janet resumed metalworking, once again seeking out casual apprenticeships to broaden her metalworking skills. She observed the processes used in a foundry and worked as an assistant to a manufacturing jeweler. To gain insight into the methods used by ancient metalworkers, she studied jewelry exhibited in museums. She observed the procedures used by Japanese metalworkers who were restoring antique armor owned by The Metropolitan Museum of Art. Her strong will and individualistic temperament, coupled with the belief that labor must be both artistic and educative, led her to seek out master craftsmen who controlled all aspects of their product from design through production.

Philosopher John Dewey's (1859-1952) lectures at Columbia University, which Payne Bowles had begun to attend, reinforced this practical approach to "learning by doing." A dynamic teacher and writer whose ideas were inspiring the educational community, Dewey became the leading exponent of pragmatism after the death of William James in 1910. Dewey extended the movement's principles to key areas of daily life.

Dewey urged the teaching of handicrafts for their cultural and social significance as well as for sheer enjoyment. His advocacy of learning by experimentation and experience had a revolutionary effect on education and educational

philosophy in the early decades of the twentieth century. Many of his ideas were adopted by the "progressive movement" in education, which stressed learning through activity rather than formal training, and vocational training rather than the mastery of traditional subjects.[17]

By 1909, when Payne Bowles's metalwork received the Spencer Trask Award from the National Society of Craftsmen and when she numbered Sir Caspar Purdon Clarke and J. P. Morgan among her clients, she was acknowledged as a master craftsman.[18] Despite such professional recognition, however, Payne Bowles still perceived herself as a "writer of books" rather than a professional metalworker.[19] She continued to assist her husband with his books, as Joseph Bowles indicated in a 1910 letter to Frederic Allen Whiting, secretary of the Society of Arts and Crafts in Boston. Joseph wrote, stating that "she still does illuminating for me and would be delighted to hear from you if you have inquiries for the barbaric sort of design in which she works most naturally."[20] This lack of confirmation of Janet's success as a craftsworker—by herself as well as by her husband—may have reflected an unwillingness on her part to abandon the notion of a literary career. Or, it may have reflected Joseph Bowles's reluctance to acknowledge that his wife had achieved the status of a craftsman in her own right and no longer remained in his shadow.

In the summer of 1910, Frederic Allen Whiting asked Payne Bowles to write an article for *Handicraft*, the Boston Arts and Crafts Society's publication. She agreed, pending completion of her commission for theatrical jewelry and accessories from the actress Maude Adams. Payne Bowles's workshop was located in the building that housed her husband's fine arts press. As Payne Bowles's metalworking skill increased, she moved from making small pieces of jewelry to executing large pieces of handwrought metalwork. Her self-confidence and dedication to perfection seem to have increased simultaneously, along with her determination to make a living wage from such demanding labor.

"The craftsman has been taught that his work is different and better, but it must be more, it should include all the science of its mechanics, as well as the art of the individual," Payne Bowles wrote that summer in her article, "A Situation in Craft Jewelry," for *Handicraft* magazine.[21] The realities of the marketplace dictated that a craftsman must make his ideals marketable, creating work superior in design and quality to that of commercial jewelers, or remain an underpaid idealist. Talented craftsmen who underpriced their work reduced the livelihoods of their fellow workers; those who refused to learn how to use modern metalworking tools and techniques, she warned, would remain conspicuous amateurs.

Payne Bowles's decision to discuss the economic realities of the marketplace rather than artistic philosophy reflected her increasing maturity as a craftsworker, as well as the chaos that reigned in the Arts and Crafts movement. As commercial manufacturers offered cheap machine-made versions of the distinctive jewelry and metalwork, demand for the handcrafted originals declined. At the same time, professionals had to offer increasingly sophisticated and well-made products in order to compete with the manual arts students and hobbyists who were turning out their own handmade jewelry and metalwork.

Fig. 11. Janet, Mira, and Jan Bowles at Helicon Hall, ca. 1907. Photo: Indianapolis Museum of Art.

Besides being well aware of the challenges facing the "craftsman jeweler," Payne Bowles must have begun to realize that she would have to become financially independent in order to support her two young children. Since leaving Indianapolis, her husband had not held a job longer than two years. Perhaps Joseph could not get along with his non-artistic, market-oriented employers. But it is equally likely that he believed that he was being asked to compromise his talents by commercial publishers and yearned to be his own boss. Most likely, however, his work suffered as a result of a drug addiction, which, according to a Payne descendent, made it impossible for him to support his family. Over the next two years, the Bowleses' marriage deteriorated rapidly, and, in the spring of 1912, Gavin Payne traveled to New York to bring his destitute sister and her two small children home to Indianapolis.[22]

Indianapolis: Metalworker and Teacher

In the summer of 1912, several factors coincided to provide Janet Payne Bowles the opportunity to begin the fourth and final phase of her career as an educator. In June, Harry E. Wood, who had been teaching jewelry and silversmithing at Indianapolis's Shortridge High School, had been promoted to director of manual training for the Indianapolis public schools. That same month, Frederic Allen Whiting became director of the John Herron Art Institute. It seems likely that Whiting, aware of Payne Bowles's ability, recommended that she be hired as the high school's instructor of art metalwork.

In this final phase of personal growth, Payne Bowles would institutionalize the tenets of the Arts and Crafts movement through her work as a teacher. At age thirty-nine, Payne Bowles began her career at Shortridge High with no formal training as a teacher but with a strong commitment to the principles of James and Dewey. Rather than following pre-cut patterns or books, she taught her students to make jewelry using their minds as well as their hands (see Fig. 12). Basic tools and equipment were introduced, with instructions on how to use them safely. Payne Bowles observed each student's progress, providing advice or demonstrating a technique. Her teaching methods were summarized by Rena Tucker Kohlman, a local sculptor and art critic, who observed: "In producing her designs she does not use pencil and paper but evolves the forms that the metals themselves suggest as she works and she teaches her pupils in the same way to induce 'the creative flow' in art."[23]

Outside the classroom, family, fellow teachers, and other women offered friendship and companionship. Payne Bowles resumed membership in the Portfolio Club, presenting a talk on the situation in the metal crafts in 1913 and serving as vice-president the following year. She attended the club's monthly meetings for the next thirty years. Equal intellectual exchange of ideas was also provided by a group of women who met regularly in her home to take the psychology classes she taught using the "system" of James and Dewey.[24]

Although she never legally divorced her husband, Payne Bowles assumed full responsibility for the support of their children. Relatives in town and friends in

the Portfolio Club undoubtedly knew that Joseph was still alive, but she did not contradict — and probably fostered — the public perception that she was a widow. For a high school faculty member in a conservative midwestern city, widowhood would have been considered a far more respectable state than being divorced. She was content to adopt the public profile of a conventional middle-aged school teacher in exchange for security and safety for her children. Like many in the first generation of new women who came of age in the 1890s, Payne Bowles was a "reluctant modernist," willing to entertain the challenges and possibilities of modernist streams of thought, but unwilling to reject the Victorian ideals and standards associated with morality, religion, and human progress.[25]

For the next ten years, Payne Bowles's life centered on Mira and Jan, with home and school activities designed to amuse and educate her young family. As a single mother, she strove to provide her children with the stable home environment that she herself had experienced. On Sundays, the family attended church, where Mira and Jan joined scout troops and Janet belonged to the Browning Society, which met at the church. Recalling her childhood, Mira wrote of her mother:

> In personality she was very warm and demonstrative and wherever she lived made very close friends. Also, she had a strong romantic streak, very unusual in someone as intellectual as she was, as evidenced by her choosing my name and the fact that she often referred to her children as Mira, the Wonderful . . . and Jan, the Invincible. Also it was typical of her that she sometimes said, like Cornelia, "These are my jewels," meaning her two children.[26]

Payne Bowles's "strong romantic streak" found expression in the Christmas tree lore that the family embraced as a holiday tradition. After tracing the history of the Christmas tree and the symbolism of its decorations, Janet shared her research through lectures and an exhibit at the John Herron Art Institute. In 1916, this culminated in the publication of *The True Story of the Christmas Tree* by Dunstan & Company of New York. The publisher, a former editor at Doubleday-Page who had worked on Payne Bowles's novel, also agreed to republish *Gossamer to Steel*, which Janet reconstructed using her old notes. The novel, bearing a misty art photo of Payne Bowles on the jacket, was published as a "second edition" in 1917. Mira, a professional writer, later commented that its "style is extremely flowery Victorian and sounds completely unlike my mother as I knew her. The book on the history of the Christmas tree reads exactly as she talked."[27] Many years later, recalling the story of the novel's rejuvenation for a newspaper reporter, Payne Bowles wistfully described it as a story of a girl's soul, adding "and the sin of my youth."[28]

Payne Bowles's organization of the Art Appreciation Club in 1916, when Mira was fourteen and Jan was twelve, allowed her to lead her students and her children in the exploration of all the cultural resources of Indianapolis. The club's weekly meetings stressed the emotional as well as the physical aspects of art. "The object is to get the habit of emotional reaction from great works of art and their enjoyment," explained a *Shortridge Daily Echo* reviewer.[29]

In 1929, when she was asked to teach pottery as well as metalwork, Payne Bowles applied the same "hands-on" approach that she used in teaching metalwork. "I didn't know how to make a pot," she told a newspaper reporter:

> I knew a wheel was used. I know some of the things the Egyptians and Romans had to do—so I got some clay, spent from 6 in the morning until 7 at night on Saturday and Sunday making pots—and took the class on Monday. [30]

Later she took a summer course taught by celebrated ceramist Charles F. Binns at Alfred University, New York. Although Payne Bowles may have come to enjoy the ease with which she could shape the soft plastic clay, the shapes of her pottery bore a striking resemblance to the forms she created in silver. Glazed with glossy metallics, one remaining example of her work, a pitcher (Pl. 70), displays a wrinkled spout on a hard angular body. "It was said that she took the jeweler's approach to pottery. Characteristically, her pot handles had the fluidity of entwined copper wire. Clay, a medium even more malleable, was an obvious joy to her," commented a former student. [31]

The same methods used to teach jewelry making were used in the course on pottery. Students would sit together at tables experimenting with the wet clay, while Payne Bowles reminded them of the principles of design and encouraged them in their work. Here, the joy of creation and a working knowledge of the material, rather than perfection in execution, were the goals. As one of her best pottery students recalled, Payne Bowles always "wanted us to express ourselves, to make something different, not just like everybody else." [32]

Payne Bowles applied practical psychology and various tests to help her students improve memory and develop good work habits. "In case a pupil cannot remember to replace tools daily practice is given until he does this involuntarily," a student reporter noted. [33] Rather than reprimand her students, Payne Bowles challenged them to change their behavior with lighthearted games derived from her interpretation of the theories of William James. "Today he is deemed old-fashioned by some," she later told a reporter, "but we still hold to physiological psychology." She was so impressed with James's essay on habit that she suggested it be printed in special form for high school students. [34]

A feverish immersion in her own metalwork and private commissions offered her a mental escape from daily routine. Working on her own commissions three hours a day, she entered a state of dreamlike reverie as unique silver and gold objects took shape in her hands. "Quiet but intense in manner, she talks of her work with a passion that glows in her gray-blue eyes. Her efforts to express the universal and the eternal take form in strange, rhythmic patterns," it was observed in 1924. [35] Money from the sale of silver chalices and other ecclesiastical commissions funded Mira's college education. Exhibits of Payne Bowles's jewelry continued to bring cash prizes and additional commissions. Perhaps, most of all, her work provided an emotional release that transcended time and place.

Before Mira and Jan graduated from high school (in 1919 and 1922, respectively), the family spent summers with Joseph Bowles in Long Beach, near New York City, where Janet commuted to work at Gorham or other workshops to

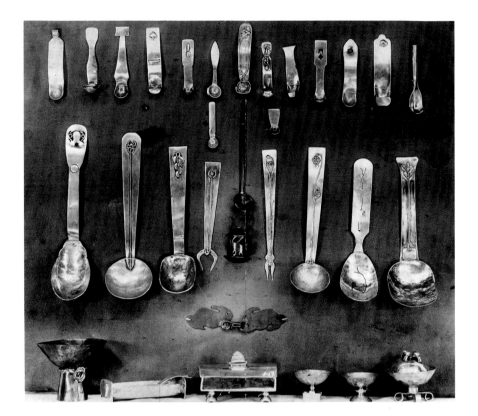

Fig. 12. Display of metalwork by students of Janet Payne Bowles, ca. 1921. Photo: Indianapolis Museum of Art.

acquire new skills or complete the private commissions that would fund the children's college educations. In 1925, Janet celebrated Mira's graduation from New York University with a summer trip to Europe. The new freedom from college tuition payments was reflected in other trips abroad, as well: she visited Italy in 1926 and Paris and Moscow in 1927.

In 1928, Payne Bowles accompanied John Dewey and a group of educators on a tour of Soviet Russia to study its educational system. Dewey was so favorably impressed with the Soviet educational system that he wrote a series of articles sympathetic to the regime. Payne Bowles, it seems, was more impressed with the iconography of the art than with the schools and incorporated her observations in lectures on Russian art that she presented for several years.

In the late 1920s, Payne Bowles began to stress practical skills and techniques that could be applied in many fields of employment. This renewed emphasis on manual art was reflected in the organization by Payne Bowles in 1927 of the Workmanship Guild, whose members were chosen on the basis of skill and character. The guild's creed of "honesty in work," and stress upon enjoyment of that work for "the growth of [the worker's] soul," revealed that Janet was still a missionary in the arts and crafts crusade.[36]

At least one of her students became a professional jeweler. Another, who served as shop assistant from 1931 through 1935, was so well trained that he

went to work for the local Herff Jones Company, the country's largest high-school jewelry manufacturer, until the outbreak of World War II. Others went on to major in art in college.[37] Students hoping to enter dental school also signed up for Payne Bowles's art metal classes, since skill in working metal, particularly gold, and the delicate touch required for jewelry making were excellent preparations for dentistry. One such student later became a successful pharmacist.[38]

Janet's own children chose careers in the arts: Mira became a writer and Jan an artist. She also made a lifelong impression on many of her students, some of whom, fifty years later, could recite the basic principles of art, and remembered with pleasure her classes. Asked by a reporter in 1932 why she remained a teacher when she could have her own shop, Payne Bowles replied:

> I continue to teach ... because I love it, and I love it because I know of nothing more stimulating to the artist or to the act of the artist than the thrill of youth in response to the call of the beautiful and the creative." [39]

In the 1930s, Janet, now in her sixties, continued to dress in an individualistic style with little regard for current fashion. She always wore jewelry, usually a brooch, a practical ornament that would not impede the agility of hand and body required for metalworking. A pottery student from 1938 through 1940 provided this physical desciption: "With sparkling blue eyes and grey-brown hair drawn back in a somewhat careless bun, in appearance Janet Bowles resembled, I would say, a more graceful version of poet Marianne Moore," adding that "her mind was every bit as disciplined."[40]

Payne Bowles's apartment also reflected a preference for simplicity and utility as opposed to decorative fads. "Her house was very 'non-fussy, non-decorative'... just honestly plain, but with beautiful pieces," a friend of Mira's recalled. "What pieces that there were, were good. The furniture was well designed. She believed that anything that had a useful purpose ought to serve that purpose."[41] As long as she lived, Payne Bowles espoused the arts and crafts belief in the simple life, epitomized by the adage of William Morris: "Have in your house only those things which you know to be useful or believe to be beautiful."

Although she turned sixty-five in 1937, Payne Bowles continued to teach, perhaps from love of her work, perhaps out of reluctance to reveal her true age (even her children were convinced that she had been born in 1876 rather than 1872 or 1873).[42] Two years later, in 1939, she presented an unusual paper to the Portfolio Club that revealed her stoic philosophy as well as an acceptance of mortality. In "The Step-Off," she debated the uncertainties of life and death, concluding that the "power to work is the most desirable quality for any existence, and suggests inherent immortality by its everlasting necessity.... With it, automatically, goes the ability to so concentrate that our very being is focalized attention." A profile of an artist-philosopher emerged: self-determined, self-supporting, and self-contained. But not selfish. And not totally self-confident: "I hope ... to find an independent death. I will not in my own last hour go social, and call hopefully for my most beloved to come to help me over the bridge that carried him home. But I suspect I will.[43]

"The Step-Off" was Payne Bowles's last literary effort. Commenting on the essay, Mira recalled that after such an unusual presentation, her mother was never asked to deliver another paper.[44] Three years later, in 1942, Payne Bowles retired from Shortridge High School at the age of seventy-four. Mira returned from New York City to Indianapolis to be near her elderly mother.

What was the legacy of Janet Payne Bowles's thirty-year career in the art department at Shortridge High School? No doubt she would have been pleased to learn that her work was on display in the local art museum, where students could examine it in their classes on art appreciation. She would have been equally proud to know that some of her students, after fifty years, could vividly recall how she taught them to make jewelry and pottery, and how to appreciate art. One student paid her a tender tribute when he said: "I think she was one to share what she had in her heart and in her hands....she was a great lady and a great teacher."[45]

Notes

I wish to thank Barry Shifman for supplying the biographical information about Payne Bowles that was used in preparing this essay.

1. For biographies and illustrations of work made in Chicago, see Darling.

2. For biographies of Madeline Yale Wynne, see Darling, pp. 63-67; and W. Scott Braznell's entries in Kaplan, pp. 264-65.

3. For additional information about Welles and the Kalo Shop, see Darling, pp. 45-55; and Kaplan, pp. 279-80.

4. For detailed discussions of the New Woman in politics, literature, and art, see Heller and Rudnick, esp. pp. 90-115; and Cotkin, pp. 74-100.

5. This copy of *The Republic* is now in the collection of the Indianapolis Museum of Art.

6. For Wynne, see Kaplan, pp. 264-65; and Darling, pp. 63, 67.

7. See Braznell's entries in Kaplan, p. 264.

8. For an overview of dress reform at the turn of the century, see Sally Buchanan Kinsey, "A More Reasonable Way to Dress," in Kaplan, pp. 358-69.

9. Quoted on the cover of *Gossamer to Steel*. James's comments must have pertained to the original draft of the manuscript since he died in 1910, seven years before its actual publication.

10. For a discussion of the influence of Gilman, see Hayden, pp. 180-277.

11. "The Sinclair Colony," *New York Times*, June 24, 1906, p. 8.

12. "Helicon Hall Has Taken to Bloomers," *New York Times*, Feb. 14, 1907, p. 16.

13. Kelley, p. 37.

14. Idem, p. 38.

15. For additional information on the daily routine, see "Helicon Hall . . ." (note 12), p. 16; *New York Times*, Oct. 7, 1906, p. 2; and Upton Sinclair, "A Home Colony," *Independent* 60 (June 14, 1906), pp. 1401-08.

16. *Indianapolis News*, Mar. 18, 1907, p. 3.

17. John Dewey (1859-1952) published his influential book, *The School and Society* (1889), while on the faculty of the University of Chicago, where he founded the Laboratory School in 1896. He began teaching at Columbia University in 1904.

18. Clarke (1848-1911) served as director of The Metropolitan Museum of Art from 1905 through the summer of 1909. J. P. Morgan (1837-1913) was elected president of the museum in 1904. For more on these two, and on the nature of the prize and commissions, see W. Scott Braznell's essay in this catalogue.

19. New Jersey State Census, 1910. New York Public Library.

20. Letter, March 22, 1910, in the archives of the Boston Society of Arts and Crafts, Boston Public Library.

21. Bowles 1910, pp. 309-20.

22. Verbal communication between Barry Shifman, associate curator of decorative arts, Indianapolis Museum of Art, and Frederick Payne, November 23, 1990.

23. Kohlman 1924, p. 55.

24. Letter from Mira Bowles to Catherine Lippert, former curator of decorative arts, Indianapolis Museum of Art, January 1982, in the Janet Payne Bowles Archives, Indianapolis Museum of Art.

25. For a discussion of transitional movements at the end of the nineteenth century, see Cotkin.

26. Letter from Mira Bowles to Catherine Lippert (note 24).

27. Ibid.

28. Stewart, p. 14.

29. *Shortridge Daily Echo*, Feb. 25, 1925, pp. 1, 4.

30. Stewart, p. 14.

31. Letter from Minerva Long Bobbitt (Berea, Kentucky) to Barry Shifman, associate curator of decorative arts, Indianapolis Museum of Art, n.d. (1991).

32. Grace Ferguson Haugh, transcript of Janet Payne Bowles oral history session, Indianapolis Museum of Art, April 24, 1991, p. 22.

33. *Shortridge Daily Echo*, Sept. 22, 1921, p. 1.

34. Stewart, p. 14.

35. Kohlman 1924, p. 54.

36. *Shortridge Daily Echo*, May 17, 1927, pp. 1, 3.

37. Arthur Ellis, transcript of Janet Payne Bowles oral history session (note 32), pp. 13-14.

38. Frank Lobraico, transcript of Janet Payne Bowles oral history session (note 32), p. 37.

39. Buschmann, p. 18.

40. Letter from Minerva Long Bobbitt to Barry Shifman (note 31).

41. Grace Ferguson Haugh (note 32).

42. It is not known why Payne Bowles claimed that she was born in 1876 rather than 1872 or 1873. In her entry in *Who's Who in American Art* for 1936-37 (vol. 1, p. 55), she claimed a birth date of June 29, 1884. However, this may have been a typographical error made by the publisher.

43. Bowles 1939. This statement came two years after Joseph Bowles had died.

44. Bowles 1939, typewritten comment recorded by Jerome Sikorski in notes at the end of the manuscript.

45. Frank Lobraico (note 38), p. 42.

The Metalcraft and Jewelry of Janet Payne Bowles

by W. Scott Braznell

Janet Payne Bowles's legacy of metalcraft and jewelry is accompanied by little beyond newspaper clippings and annotated period photographs of her work, and lacks a body of documentary evidence such as diaries, correspondence, and receipts. One unpublished essay entitled "The Step-Off," containing Payne Bowles's views on death, now survives in the collection of Jerome Sikorski.[1] The extant works comprise one hundred and twenty-five items, all of which the artist's children, Mira and Jan, inherited and donated to the Indianapolis Museum of Art between 1968 and 1981.[2] The museum's collection of metalcraft includes chalices and boxes, but consists mostly of spoons and other flatware; its jewelry holdings consist mostly of rings, but include necklaces and cross pendants. In addition, photographs in the museum's archives record some twenty-seven rings and several other pieces of jewelry whose whereabouts remain unknown.

The photographs are rife with various annotations made by different individuals at different times. A few provide vital information for dating Payne Bowles's metalcraft and jewelry. But other tantalizing annotations on other photographs which refer to international awards and eminent patronage both in the United States and abroad remain puzzling. In many cases, the similarity between works in the Indianapolis Museum of Art's collection and those shown in period photographs annotated as being commissions has led some scholars to interpret a large portion of Payne Bowles's work as studies or models for those commissions.[3] However, close comparison of the museum's works with those in the photographs show them to be one and the same (although, over the years, some of the objects were reworked by Payne Bowles). Significantly, no works have been located from the numerous prestigious private and ecclesiastical commissions repeatedly cited by Payne Bowles and the press during her lifetime, and the inability to confirm any of these commissions leads to the presumption that Payne Bowles invented them to serve her own creative needs.

Nevertheless, the metalcraft and jewelry of this overlooked and idiosyncratic artist-metalsmith triumphs on its own. It resonates with an uncommon personal passion and enriches our understanding of the attitudes and aspirations held by early twentieth-century artists and craftspeople.

Plate 4. *Cross pendant with chain*, ca. 1907-11 (cat. 3)

The Command of Metal: 1895-1912

... but what countless designs from the phenomena of Nature, from legend, from child- and animal-life, and how they differ from the grotesque flower-patterns and the nondescript motifs of the present inartistic commercial stuffs.

Janet Payne Bowles[4]

At the turn of the twentieth century, the medieval and pan-Celtic worlds were among the pre-industrial cultures whose motifs and fabrication methods were being revived by the Arts and Crafts movement. In America, craftsmen such as Bruce Rogers recreated the decorative detail of medieval art in book design of the 1890s, while silversmiths such as Arthur J. Stone and Horace E. Potter employed Celtic *entrelac* designs in their work.[5] The recent exhibition and publication *Imagining An Irish Past: The Celtic Revival 1840-1940* discusses how Chicago's 1893 Columbian Exposition brought Celtic art to the attention of American craftsmen.[6] The atmosphere that encouraged Janet Payne to embrace Celtic art was forming in 1892 when her future husband, Joseph Moore Bowles, became acquainted with medieval-style printing from William Morris's newly founded Kelmscott Press. Janet Payne Bowles was attracted to the powerful spirituality of Celtic and medieval art—art she found appropriate to invoke her deep and reverent feelings about the universe and eternity. This interest would have mirrored and been reinforced by the lectures on psychology she attended given by William James.[7]

Payne Bowles's first known art work was illuminating initials designed by Bruce Rogers for R. B. Gruelle's *Notes: Critical & Biographical* printed in 1895 by Joseph Bowles, who began working with Rogers about 1890.[8] The young Janet Payne knew Rogers and Bowles prior to 1895 through her membership in the Portfolio Club of Indianapolis. A copy of the *Notes* was exhibited at the 1899 exhibition of the Society of Arts and Crafts in Boston, and again in 1901 at the Providence Art Club.[9] Regrettably, none of the extant copies of the *Notes* was illuminated by Payne Bowles.

The earliest Payne Bowles works to survive are Celtic-inspired illuminations in four copies of *The Second Epistle of John* published by her husband in 1901.[10] The title page of one copy renders the letter "J" in a style that recalls the "Chi-Rho" page from the Book of Kells. In the second copy, Payne Bowles arranged the title page with scroll interlacing that recalls the knotwork found on the cross page from the Lindisfarne Gospels.[11] The title page of the third copy (Pl. 2) is a rhythmic and colorful flat-patterned arrangement of wide-eyed birds and wormlike creatures. And the fourth and last extant copy yields a title page vibrant with long-necked animals interlocked with hook-end tendril forms enlivened by voids or spots and all arranged like pieces in a picture puzzle.

The configuration of scroll interlacing and animal forms in Payne Bowles's illuminations resembles entwined foliate tendrils and animals by Rogers in decorated pages of the 1896 edition of Thomas Bailey Aldrich's *Friar Jerome's Beautiful Book*.[12] The flat-patterned interweaving, the tendril and vermicular shapes with knob ends, the contrast of solids and voids, and the wide-eyed creatures in

these illuminations reappear later in Payne Bowles's early jewelry, such as a cross pendant (Pl. 4). Payne Bowles continued making illuminations for her husband until at least 1910, but by then she was giving most of her time to making jewelry.[13]

Payne Bowles's interest in metalcraft and jewelry may have originated through her acquaintance with Chicago metalcrafter and jeweler Mary Elaine Hussey. The catalogue for the 1899 exhibition of the Society of Arts and Crafts in Boston lists Payne Bowles as the lender of "metal ornaments" designed and executed by Hussey. Scant information exists on Hussey and no examples of her work are known. She was a member and participant in the first exhibition in 1898 of the Chicago Arts and Crafts Society, where she exhibited two gold buckles and a bronze clasp, each set with stones, and a book-cover in calf ornamented with carved disks of bronze, set with cabochons of pink coral. The catalogue for the 1899 inaugural exhibition of the National Arts Club in New York City states that Hussey contributed a cast and chased silver belt buckle and cast and chased silver garter clasps with and without jewels.[14] It seems significant that Payne Bowles's first jewelry efforts were also cast.

Payne Bowles evidently first learned metalcraft in Boston in 1900 or 1901 when she pursued her chance acquaintance with a Russian metalsmith who apparently was also an intellectual with anarchist views.[15] The Russian, a young man making metalwares by hand in a small shop, was probably carrying out the kind of vernacular work Boston's Society of Arts and Crafts was then seeking to revive. Moreover, radical ideals played a formative role in the Society's Handicraft Shop, a cooperative craftspeople's organization established in 1901, where metalcraft was the major activity.

In the century's first years, opportunities for learning metalcraft and jewelry outside the factory system were just being developed. Texts for beginning amateurs only became widely available after 1903, when English silversmith and jeweler Henry Wilson published *Silverwork and Jewelry*. It is unlikely that Payne Bowles would have been without a copy of this useful manual, as well as R. LL. B. Rathbone's *Simple Jewellery* of 1910. In addition to step-by-step instruction, both texts were liberally illustrated with examples of Greek, Roman, Celtic, and medieval metalcraft and jewelry. In a 1942 interview, Payne Bowles recalled her difficulties in acquiring metalcrafting skills: "All skilled craftsmen are jealous of their skills and will not wittingly teach you their secrets."[16] However, Payne Bowles acquired sufficient knowledge and experience to achieve important recognition by 1910.

In 1907, after resettling in New York City, Payne Bowles was able to open her own shop on 28th Street, where Joseph Bowles had his press.[17] The times were auspicious for her interests. During the previous year the National Society of Craftsman was formed with headquarters in New York. Arthur Wesley Dow, whose influence on Payne Bowles's art and life is discussed later, served as founding vice-president.[18] A year later, when the National League of Handicraft Societies was formed, Dow and Madeline Yale Wynne, a Chicago-based arts and crafts leader well known for her jewelry and metalcraft, were elected vice-presidents.

Payne Bowles was acquainted with the Greek, Roman, and Egyptian collections at The Metropolitan Museum of Art. Over the years, she recalled in newspaper interviews her frequent visits there and acquaintance with Sir Caspar Purdon Clarke (1846-1911), the museum's director.[19] In 1908 she evidently had useful guidance from observing the metalcrafter K. Okabe, one of two Japanese craftsmen employed at The Metropolitan Museum of Art to clean, repair, and plan for the re-arrangement of the museum's Japanese metal collections.[20] Payne Bowles may also have been inspired by antique metalcraft and jewelry regularly included in exhibitions of contemporary arts and crafts or published in periodicals such as *House Beautiful* and *The Craftsman*.[21]

Annotations made by Payne Bowles at an unknown date on a photograph suggest she exhibited three pendants in New York and was given the "Trask prize" about 1909. Spencer Trask, who died in a train wreck on December 31, 1909, was president of the National Society of Craftsmen in New York. The pendants may have been in the Society's third annual exhibition in December 1909, but there is no record of them or of the Trask prize. A silver pendant (Pl. 13) and a fluted bronze pendant (Pl. 17) seen in the photograph may be the earliest surviving examples of Payne Bowles's jewelry. The bronze pendant was cast just as the Bronze Age Celtic jewelry it recalls was cast. The silver pendant was also cast, and the animal faces overlooking a lapis lazuli heart are comparable to the ornamental patterns and animal faces that appear in Celtic and early Nordic art (see Fig. 13).[22] This jewelry would bear out the assessment Joseph Bowles made of his wife's work in 1910 that it was "the barbaric sort of design in which she works most naturally."[23]

By 1910, Payne Bowles's work had attracted sufficient interest that Maude Adams, then a widely celebrated actress, commissioned Payne Bowles to make jewelry and metal accessories for her role as Rosalind in Shakespeare's *As You Like It*. A full-length portrait of Adams from *The Theatre* for July 1910 shows her with the complete ensemble (see Shifman essay, Fig. 4), which also included a spear and a dagger.[24] An unidentified newspaper illustrated the silver curtle ax, or dagger, and noted that "the jewelry which Mrs. Bowles designed is of carved silver, set with green onyx stones, . . . elaborate in detail, yet simple in homogeneous effect."[25] The present whereabouts of the jewelry is unknown, but the photograph conveys enough of Payne Bowles's style to reveal its Celtic and Roman influence.

Also in 1910, Frederic Allen Whiting published Payne Bowles's article "A Situation in Craft Jewelry" in the December issue of *Handicraft*, and it appeared soon thereafter in the *Jewelers' Circular Weekly*.[26] In the essay, Payne Bowles admonished amateurs and cautioned successful professionals on the pitfalls of competing with commercial jewelry. She also urged craft jewelers to pursue a thorough familiarity with materials and techniques with this advice:

> *"The knowledge of the chemistry and geology of his material will give him as much psychic power in work as a great sensitive knowledge of design. Its wide knowledge gives him imaginative fuel, and he finds himself trying to produce effects etherially conceived. This is the spiritual process of enlarging the limitations of his craft."*[27]

Fig. 13. Cast bronze brooch, Swedish, ninth century. State Historical Museum, Stockholm (inv. no. 1476).

Reviews of the 1910 annual exhibition of the National Society of Craftsmen (New York) gave favorable mention to Payne Bowles's work, and in the *International Studio*, J. William Fosdick commented on her carved silver cross set with a cat's eye, observing that her work was "Celtic in spirit" and "carried out in a broad, free spirit which is most commendable."[28] Regrettably, a cross pendant with cat's eye is not among the surviving pieces of her work.

The illustrations of Maude Adams's jewelry and the exhibition review calling her work "Celtic in spirit" suggest that a portion of Payne Bowles's surviving jewelry work can be attributed to this early period of her career. Celtic fabrication methods and motifs are seen in two cross pendants, one gold with an amethyst and green glass (Pl. 12), the other silver with a tourmaline (Pl. 4). These pendants, like a belt buckle later reworked as a pendant (Pl. 14), were most likely cast from wax models and share elements of the flat-pattern braided "tangle" arrangements in Payne Bowles's earlier text illuminations.[29] The tourmaline cross pendant especially recalls the mysterious and restless interlaced forms of wide-eyed animals and birds. The belt buckle frames a design similar to the churning coil forms best seen in the Steele family illumination (Pl. 2).

Greco-Roman influences are also apparent in Payne Bowles's jewelry from this period. The cross pendant already mentioned (Pl. 4) has a chain design found in Roman jewelry, which Payne Bowles may have known through Rathbone's text (see Fig. 14).[30] The chain on another cross pendant (Pl. 18) also relates to Roman examples, and a pendant (Pl. 5) has a triad grouping of drops suspended from a central boss that recalls later Roman earrings (see Fig. 15).[31] Christian symbols are also evident in Payne Bowles's early work. Examples with crosses include a cast silver pectoral cross (Pl. 38) with lapis. Shaped like a Roman "key" ring, a silver and gold ring displays the "Chi-Rho" monogram of Christ (Pl. 22).[32]

With metal Payne Bowles had found the world in which she wanted to operate. In a 1930 interview she said, "The only work that counts . . . is, of course, that which affords the opportunity for complete and satisfying self-expression."[33]

Fig. 14. Gold chains, Roman, first to fourth centuries. British Museum. Photo: R. LL. B. Rathbone, *Simple Jewellry* (New York, 1910), p. 201, fig. 70.

Fig. 15. Earrings, Visigothic, sixth century. Walters Art Gallery, Baltimore (no. 57.560.561).

The Creative Flow: 1912-1924

The beauty of proportions . . . is measured by your feeling for fine relations, not by any formula whatever. No work has art-value unless it reflects the personality of its author. Arthur Wesley Dow[34]

The design laws of rhythm, balance and harmony I must feel into the work, not as rules of composition, but as the inevitable force of gravity, and the movement of spheres in the natural universe. Janet Payne Bowles[35]

In the spring of 1912, after spending her young adulthood moving in the artistic circles of Boston and New York, Janet Payne Bowles separated from her husband and returned to her mother's home in Indianapolis. On the threshold of middle-age, Payne Bowles sought a suitable environment in which to raise her children. After seventeen years at the pulse of American arts activities, this retreat might have become an exile, but with Payne Bowles this was not to be the case.

Upon her return to Indianapolis, Payne Bowles was met with interest and support for her accomplishments as a metalworker and an artist. In October 1912, the *Indianapolis News* reported that she and Roda Selleck would conduct classes in metalwork and pottery at the John Herron Art Institute. The same month, the *Shortridge Daily Echo* reported that Payne Bowles was contemplating teaching an advanced course in art metal. By February 1913 the class had been formed.[36]

The exact circumstances that preceded Payne Bowles's engagement as instructor of Shortridge High School art metal classes are not known, but in April 1912 a series of events can only be seen as auspicious for her return. Harry Wood, who had recently resigned his position as instructor in art metal at Shortridge, returned to the school to speak on his former subject. There is little doubt that Wood, who was newly appointed as head of the manual training department of Indianapolis public schools, would have known the essay "A Situation in Craft Jewelry" by Shortridge graduate Payne Bowles. Two days later, on April 13, Payne Bowles's jewelry was on view at the John Herron Art Institute's Fifth Annual Exhibition of Indiana Artists. Also in April, Payne Bowles's colleague, Frederic Allen Whiting, resigned his post at the Boston Society of Arts and Crafts to begin in June as the director of the John Herron Art Institute.[37]

As early as December 1913 the Indianapolis press reported that Payne Bowles was at work on a set of spoons commissioned by the J. Pierpont Morgan estate. Through her relationship with Sir Caspar Purdon Clarke in New York, Payne Bowles had been introduced to J. Pierpont Morgan, president of The Metropolitan Museum of Art. Morgan, who was an avid collector of ancient jewelry and metalwares, doubtless had some understanding with Payne Bowles that motivated her to commence work for him and, following his death in March 1913, to continue this work for his estate and heirs. Although the Indianapolis press reported Payne Bowles's progress on this work, correspondence, invoices, or other confirming evidence for this commission are unknown.[38]

PLATE 5

Pendant with chain
ca. 1910-12
cat. 14

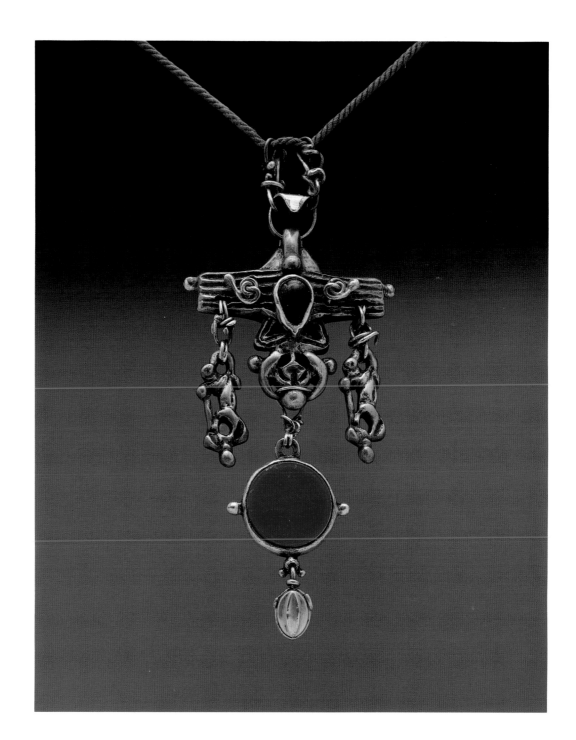

The gold and jewel-inlaid spoons for Morgan mentioned in the Indianapolis press between 1913 and 1920 presumably correspond to those illustrated in a 1924 profile on Payne Bowles in the *International Studio*, where they were captioned "Gold Spoons Made For J. Pierpont Morgan" (see Fig. 16).[39] Close study reveals that all but two of the spoons illustrated in the 1924 article survive in the Indianapolis Museum of Art's collection: but they are made of silver, and although the ring terminal of one spoon (Pl. 29) may have originally held a jewel, none is presently embellished with jewels. Most of the spoons published in 1924 as having been made for Morgan were probably completed by 1915. The curls, beads, and snips on one spoon (Pl. 26), although built up out of molten globs and drips and fused snips and wires rather than being cast, relate to Payne Bowles's earlier interlaced and vermicular work. Moreover, another spoon (Fig. 16, bottom, second from left) employs twisted wire reinforcement at its bowl handle that continues her earlier practice of twisted wire seen in the jewelry adorning Maude Adams's shoulder (see Shifman essay, Fig. 4), in a pendant (Pl. 15), and "Roman" style pendant (Pl. 5), which also shares the triangular pediment shape of the spoon's handle terminal. In addition, some of the "Morgan" spoons also continue Payne Bowles's practice of invoking a mood of spirituality with Christian symbols and avian and zoomorphic forms. The handle of one such spoon (Pl. 36) depicts the crucifixion of Christ on the end of its handle; and yet another spoon (no longer extant, but recorded in a 1917 view (Fig. 17), has a handle that incorporates what appears to be a figure peering from a window topped by a rooster and a bowl joined to the handle by a head and arms.[40] Like Payne Bowles's earlier jewelry, these spoons, through intricate detail and arrangement, capture the expressive power and mystery found in early religious art. Another factor that links some of the "Morgan" spoons to Payne Bowles's earlier work is references to Roman art. The narrow rodlike handles of two spoons (Pls. 29, 35) recall those of Roman spoons.[41] Three other spoons (Pls. 23, 24, 34) may also date from the period of the Morgan spoons because they share this characteristic.

Other "Morgan" spoons (Pls. 25, 28; cat. no. 52) mark innovations in Payne Bowles's formal design vocabulary: they exhibit a hitherto unseen emphasis on silhouette. Silhouette is dominant in several spoons (Fig. 16, top, far left; Pl. 45; cat. no. 59) and provides the background for an overlay of soldered and fused elements that exhibit the complexity and mystery of the earlier cast zoomorphic motifs. However, where Payne Bowles previously constructed form out of interlaced vermiform elements, here she composed in a sequential, additive process that induced what she termed "the creative flow."[42] In a manner typical of her later work, her fabrication methods are a visible part of her expression.

Similarities between other Payne Bowles spoons and rings and these "Morgan" spoons suggest that they may also date from this part of her career, or about 1916 to 1920. The additive process is seen in a group of flatware whose handles are composed of flat ribbon strips (Pl. 48; cat. nos. 60, 61). The boss hammer-texture and strong outline of a ring (cat. no. 27) also evoke the Morgan spoon (Pl. 25). Like many of Payne Bowles's rings, this example is large, and when worn extends from the knuckle to the first joint of the ring finger.

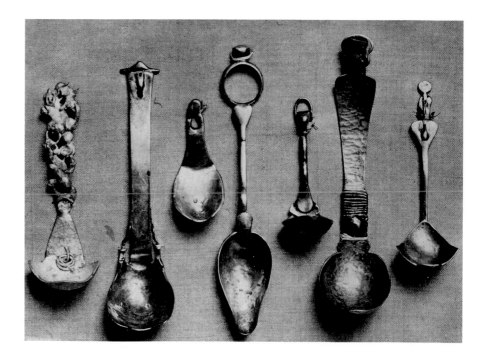

Fig. 16. Spoons made by Janet Payne Bowles, mostly by 1915. From *International Studio* (Oct. 1924).

"Craft-Woman" Plies Art in Indianapolis

MRS. JANET PAYNE BOWLES.

Payne Bowles's spoons are in everyday sizes, and all reveal a masterful sense of composition with strong but elegant line and balance. Especially indicative of her skill are three spoons (Pls. 25, 28, 36) which show imaginative opposition and repetition of shapes. Her artistic control is instinctive, but honed over time through repeated exercise. Through the constant engagement and experiment with her materials, Payne Bowles achieved a command of proportion, harmony, and balance.

A lead box (Pl. 39), one of the three surviving metal works signed by Payne Bowles, was illustrated in the *Indiana Daily Times* in 1917 (see Fig. 17) and may be the box which earned her a bronze medal at the Panama-Pacific International Exposition of 1915.[43] Although its irregular surface, richly ornamented with drips and blobs of molten lead, recalls the interlacing of zoomorphic creatures in Payne Bowles's earlier Celtic-inspired work, it has no representative images. These more abstract forms, also seen in a ring (Pl. 16), served Payne Bowles's growing interest in exploring self-expression unrestricted by conventionalization and the constraints of traditional metalsmithing practices.

A photograph from about 1918 illustrates pieces that may have been Payne Bowles's submissions to an international competition.[44] The annotation in an unknown hand reads: "Gold & Platinum Jewelry, From the Goldsmith's Exhibition, Paris, 1st prize." Two early pieces—cross pendants (Pls. 12, 18)—and four later pieces—a brooch, two rings, and a pendant on a chain—are shown (as is an unidentified ring). The later pendant (Pl. 19), which is attached to a short serpentine chain ornamented with threadlike wire nodes, consists of a tourmaline with delicate work in soldered wire, with drips and blobs that frame a tiny suspended bell. The two silver rings (Pls. 20, 21) combine round and flat wire with soldered and fused blobs and drips of molten metal. The fine handwork in the oval brooch (Pl. 30) carries through to its catch. The silver-gilt oval acts like a picture frame, but with the addition of a copper loop spilling onto the frame, the abstract composition wavers between two and three dimensions. The brooch and rings evidence a new, three-dimensional interest in spatial perception and a wider range of interrelated fabrication processes.

A 1921 photograph of her students' metalcraft (see Darling essay, Fig. 12) includes pedestal bowls and cups imitative of Payne Bowles's work. One student's work mirrors Payne Bowles's use of an inverted bowl shape for the foot of a chalice (see Pl. 44), and another's replicates the cylindrical ring of segmented sheet strips on the base of the chalice. However, the student work is static, symmetrical, and constrained by conventional ideas of form, while Payne Bowles's chalice is dynamic and rebellious in its jagged break with symmetry and preconceived notions of form. Payne Bowles's chalice communicates on other levels, too: the stem connecting the bowl and foot suggests an organic transfer of elements, the segmented ring on the foot implies the earth's rhythmic rotation, and the accretions on the cup's lip confer a special benediction to its contents.

The piece published in 1924 as "Silver wine vessel in the Bossilini Collection" (see Fig. 18) and the coffeepot given by Mira Bowles to Jerome Sikorski and now owned by the Indianapolis Museum of Art (Pl. 6) are one and the same.[45] Sadly,

the coffeepot no longer has the additions seen in the 1924 illustration. The body is a type of Russian-made pot, such as the example that appeared in *The Craftsman* for May 1902, that was also being produced in New York, where, by 1921, they were being wholesaled to gift shops.[46] Payne Bowles's vigorous yet delicate wrought additions evoke ideas of ritual use and arcane ceremonies. They also evince her awareness of the work of the Danish silversmith Georg Jensen. The spout is embellished with ornament in the manner of Jensen's "Blossom" flatware pattern (introduced in 1919), and Payne Bowles may have seen and been inspired by the Jensen exhibition at the Art Institute of Chicago on view in January 1921.[47] Payne Bowles probably exhibited the pot at the 1921 Indiana artists' annual in March.[48]

Echoes of Jensen's designs are seen in other Payne Bowles pieces that make clear the importance of his silver as a catalyst for change in her work. In the 1920s, Jensen silver was exhibited and promoted in the East and Midwest where Payne Bowles could have seen it: in May 1925, an exhibition of over one hundred pieces of Jensen's silver was on view at the John Herron Art Institute. A group of Payne Bowles's flatware is in the manner of Jensen's early flatware (see Pls. 54, 59, 62; cat. nos. 86, 92). The terminals of another spoon (Pl. 47) and a jam spoon introduced by Jensen in 1916 show a marked resemblance; a paper knife (Pl. 7) may owe a debt to the design of a Jensen sauce spoon (Fig. 19) illustrated in L. C. Nielsen's 1921 biography of Jensen.[49] Payne Bowles's Jensenesque flatware marks a significant compositional change in her work, and her pieces begin to interact with space.

With the "Sacred Tears" chalice (Pl. 52), Payne Bowles took on a more ambitious and evocative form and communicates with a heightened emotive power. Payne Bowles developed this silver chalice over a period of years. Two different stages of its development were published in 1924 (it was identified alternately as a silver cup and a gold chalice); the form had evolved more when it was exhibited in 1926; and still further refinements are seen in exhibition photographs from 1929.[50] Unlike the coffeepot or her lead box, where elements were added to the surface of a readily perceived form, here elements are used to construct the form itself. Visually, the chalice plays off an open-work base and stem whose abundant and intricate detail is a foil to the smooth surface of the cup it supports, a compositional device practiced by Jensen.[51] Abstract shapes and rich textures are unified with a keen sense for asymmetrical balance, with the cruciform base opposing the rounded cup, whose circular rim is in turn echoed in the ring handle. The play of light on molten drippings and the large expanses of reflective surface offer a rich and engaging textural world.

By the late 1910s Payne Bowles began to experiment aggressively with twisted wire.[52] It comprises a major part of her expression seen in rings (Pl. 8; cat. nos. 63, 67), and a spoon (Pl. 47) where part of a pocket watch serves as the bowl. The jewel in one ring (Pl. 49) is not so much part of a setting as it is "chained" in place. Twisted wire hair pins (Pl. 9; cat. no. 70) are virtually alive with Payne Bowles's creative energy. The interlacing seen in her earlier work breaks out into muscular, sinewy forms.

Between 1912 and 1924, Payne Bowles also began exploring new materials. In the early 1920s she was experimenting with "cupror," a new tarnish-resistant

PLATE 6

Coffeepot
ca. 1921
cat. 81

Ewer itself is probably Russian or American, 1905-21.

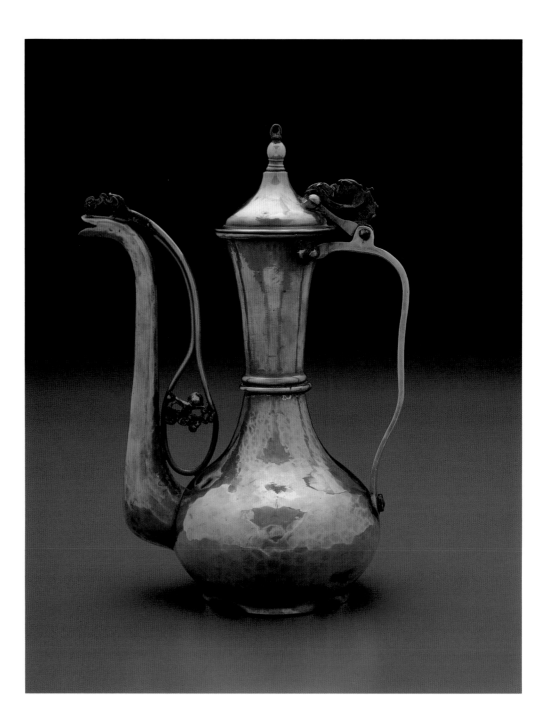

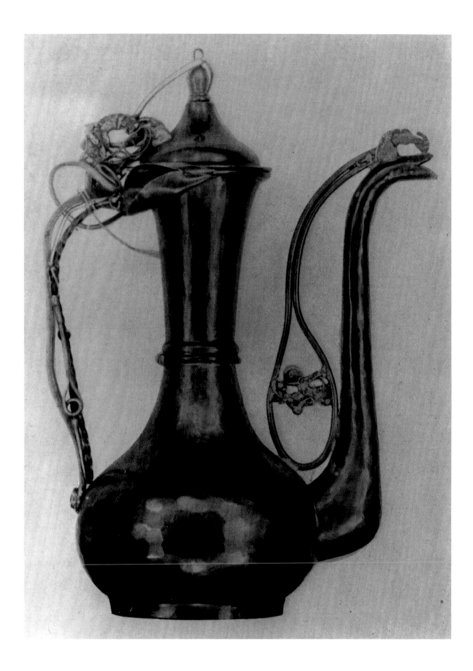

Fig. 18. Coffeepot with silver additions by Janet Payne Bowles, ca. 1921 (Pl. 6, cat. no. 81). From *International Studio* 80 (Oct. 1924).

and ductile goldlike alloy introduced in 1910 that combined copper and nickel. Three rings (cat. nos. 78, 104, 113) survive from the seven Payne Bowles listed in a 1931 inventory as including "cupra" [*sic*], but it has not been possible to verify that these rings contain this alloy.[53]

Payne Bowles was greatly influenced by the composition method of Arthur Wesley Dow (1857-1922). Although she would have been aware of Dow since her marriage in 1895, Dow's integral role in her artistic development is not readily apparent until the point at which she combined her work with teaching.[54] Dow's text, *Composition*, was first published in 1899 by Joseph Bowles in Boston

and was on view there at the April 1899 exhibition of the Society of Arts and Crafts.[55] By 1904, when the Bowles family moved to New York City and Dow came to Columbia University, Janet was already a disciple of the pragmatic teachings of William James and of John Dewey. The logical basis for education espoused by Dewey would have encouraged her adoption of Dow's principles. The Dow system guided the teaching of several generations of arts teachers and for some of them *Composition* became their bible: by 1941 it was in its twentieth edition.[56] Dow led the break with academic artistic tradition by approaching art through composition rather than through imitative drawing. He stressed "...non-applied design, knowledge of good arrangement, good form, good color, the use of lines, spots and spaces, [and] the value and significance of rhythm," as opposed to nature drawing or representation.[57] Dow taught that "the many different acts and processes combined in a work of art may be attacked and mastered one by one, and thereby a power gained to handle them unconsciously when they must be used together."[58]

Payne Bowles shared Dow's belief in art as an individual activity enhanced by spontaneity. She did not make drawings or preliminary sketches and encouraged her pupils to work in the same way and evolve form as the metal itself suggested.[59] Payne Bowles followed Dow's precepts in a number of ways according to testimony from her students. One recalled how she talked about the principles of art, such as "balance" and "proportion, rhythm, and function"—words basic to the Dow vocabulary. Another recalled Payne Bowles's working process, stating that her work had balance: "...if [a] piece wasn't right she'd ...add...something...to balance the beauty." Like Dow, Payne Bowles also eschewed symmetry: "She liked nothing symmetrical...she would say 'No, you want to start with something and add.'"[60] "Art appreciation" was also a fundamental concept of Dow's, and it is interesting to note that Payne Bowles originated her first "art appreciation" classes in 1916, just after Dow's four-part article, "Talks on Art Appreciation," ran in *The Delineator* from January 1915 to February 1916.[61]

Payne Bowles was a scholar of all periods of art history and an especially avid observer of vanguard developments at exhibitions she regularly attended in New York and other arts centers. She practiced Dow's principle of abstraction intuitively, but her accretion approach may have also been encouraged by the collage art of Georges Braque and Pablo Picasso after 1912, and by the Americans Joseph Stella and Arthur Dove during the 1920s. One pendant (Pl. 33), for example, offers a double reading: as a face or as a composition of jeweler's bits and scraps. Her visceral engagement with her materials was a working approach that paralleled the vanguard "direct carving" sculptors Robert Laurent and William Zorach. Payne Bowles may have seen their decorative wood sculpture at the Art Institute of Chicago annual arts and crafts exhibition for 1924-25.[62] These artists were interested in allowing the material itself to influence the form that took shape under their hands. Direct carving can be viewed as in the spirit of the handicraft revival eschewing the fabrication of designs by others or by machines. For Payne Bowles, her "creative flow" became the flow of molten metals with gravity and

Fig. 19. Silver sauce spoon by Georg Jensen. Photo: L. C. Nielsen, *Georg Jensen, An Artists's Biography* (1921).

PLATE 7

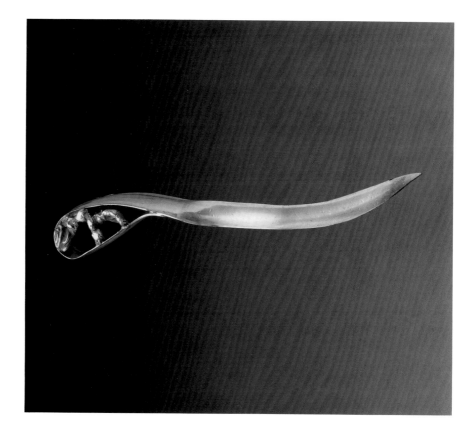

other forces of nature her ally. Soldering, fusing, and molten metal drips are well developed in Payne Bowles's work by 1920. In that year, Payne Bowles lectured as to "how the noblest design was that which followed and emphasized the construction of an object, on which was itself the object."[63]

In late 1924, Payne Bowles received important acclaim as an artist and a metalsmith. Illustrations of Payne Bowles's work and a comprehensive discussion of her artistic principles are found in the long article devoted to her by Indianapolis artist Rena Tucker Kohlman in *International Studio*. It included Payne Bowles's incisive statements: "The universal and the eternal are my favorite and abiding subjects and I am most conscious of a desire to express them in metal." Her intense interest in the spiritual with regard to religious objects was made clear: "In the objects for religious service, I have tried on the decorative side, to reverse the idea of trans-substantiation, to turn a direct symbol back into the mystery of spiritual underflow and express not history's symbol, but the emotion that produces that symbol."[64] In December, Payne Bowles displayed pendants, spoons, and rings in a group exhibition at the Art Center in New York that also included work by such prominent figures as Georg Jensen. Her work was illustrated in the *Bulletin of the Art Center* and received a laudatory review in *Art News* that identified her as "one of the most creative designers working in America today."[65]

PLATE 8

Ring
ca. 1916-20
cat. 66

PLATE 9

Hair pin
ca. 1916-20
cat. 71

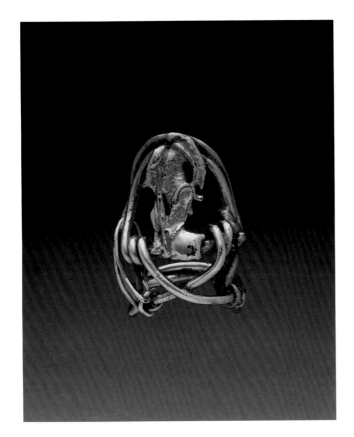

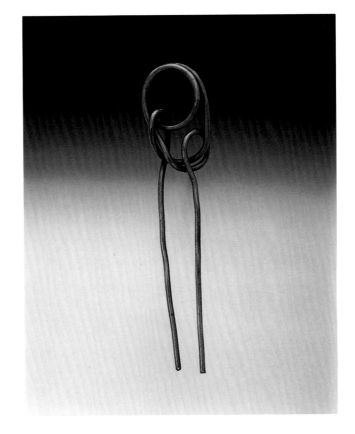

The Mature Artist: 1924-1935

*The artist must be blind to distinctions between "recognized" or "unrecognized"
conventions of form, deaf to the transitory teaching and demands of his particular age.
He must watch only the trend of the inner need, and harken to its words alone.*

Wassily Kandinsky[66]

Extraordinary development takes place in Payne Bowles's work in the late 1920s.
Space becomes an active component in compositions with the interpenetration of
elements and the opposition of solids and voids; it becomes a major focus for
Payne Bowles as she composes her forms to stand upright. Where a design previ-
ously evolved on one plane, it now breaks out to rise with explosive liberation
into exuberant ritual vessels. An expanded range of metalsmithing techniques
yields varied light and shadow effects and heightens the sense of movement. Just
as Payne Bowles's earlier representative images evolved into abstraction, her
functional forms, such as chalices, became sculpture.

In the lid of a reliquary (Pl. 69) reportedly completed for a church in Flor-
ence, Italy, Payne Bowles continued her practice of hot modeling and the fusing
of scraps of wire on sheet silver.[67] The reliquary's finial evokes a lily, the badge of
the city of Florence, and the ring handles and feet repeat the twisted wire that
Payne Bowles incorporated into earlier work (see Pls. 21, 47; cat. nos. 31, 63).
However, in the expressive use of bent, folded, and curved sheet silver the
reliquary marks an ambitious departure for Payne Bowles. The smooth reflective
surface of the sheet stock is used as a textural foil to the mottled and oxidized
handle.

Payne Bowles's use of a variety of elements to create a complex free-stand-
ing form is seen in a chalice (Pl. 1) that was the centerpiece in Payne Bowles's
solo exhibition at the Art Center, New York, in December 1929. A gold ring, or
"halo," is boldly placed on the lip of the cup; snips, filings, and lengths of wire
were soldered on the interior; and the base was composed of hammered sheet,
extruded rods, and soldered lumps. The gold thumb-ring, which aids in bringing
the cup to the lips, introduces color symbolically.

Only seven inches high, a font by Payne Bowles that was in the same exhibi-
tion (frontispiece) suggests a piece of imposing scale. Payne Bowles incorporated
an earlier hair comb she made, the teeth of which are bent to hold a receptacle.[68]
The combination, which recalls earlier ladles by Payne Bowles, stands on an
open-work pedestal base. Circular shapes, both framing and enclosing space, are
played off each other in the three spatial axes of the piece. The rest becomes an
adroit arrangement of rhythmic patterns of straights and curves, solids and voids,
that reinforce the monumentality of the composition and underscore the impor-
tance of the vessel's contents.

A large fork with a frog worked into the handle (Pl. 3), also in the same
exhibition, may have been influenced by contemporary discoveries of Incan art.
Primitive art had a significant influence on artists of the 1920s, and as early as
1911 publications were suggesting Pre-Columbian motifs to designers. In January
1926, Payne Bowles returned from a vacation with photographs of recent Incan

discoveries.[69] The compelling image in the fork, however, is the male human figure served up on the fork's tines.

Further evidence of Payne Bowles's experimentation with the perception and interaction of space and symbols is found in three serving pieces most likely made in the late 1920s. With the simple device of a ring foot on the bowl and a winged terminal on the handle, a modest-sized ladle (Pl. 53) is made to stand and with its sweeping arched handle takes on a formidable presence. A server with a figural composition (Pl. 10) offers a play of positive and negative space as well as textural contrast. A spatula (Pl. 60) challenges and delights in the visual play of the figure engraved on the mirrorlike surface of the blade and reappearing in three-dimensional form on the handle.

Payne Bowles's continuing debt to Georg Jensen is seen in a chalice or salt stand (Pl. 67). Its spirited, whirling columnar stem and sense of movement were undoubtedly inspired by designs Jensen introduced in 1918 in a spiral-stem pedestal bowl with pendant grape clusters (Fig. 20) and an oval jardiniere where opposing grape clusters were suspended from the rim.[70] But, if Payne Bowles appropriated Jensen's devices, she rendered them with a vigor and authority that are distinctly her own. This chalice, as well as two spoons (Pl. 65; cat. no. 119) whose handles also display the whirling motif, reflect light and imply movement with an intuitiveness seen in contemporary Futurist works.[71]

Two additional chalices (Pls. 68, 71) likely date from between 1925 and 1931.[72] The "Four post" chalice (Pl. 71) utilizes the square-section rod seen in the "Gold halo" chalice (Pl. 1) and an earlier font (frontispiece). Moreover, the font seems like a preliminary exercise for the "Four post" chalice. The "Four post" and "Gold halo" chalices with their narrow tree-trunk stems and loaded with accretions are highly detailed and rich in appearance and owe a debt to late Renaissance covered pedestal cups (see Fig. 21) that Payne Bowles would have known.[73] Just over nine inches high, the "Four post" chalice rises to a cloudlike cup, but the foursquare base over which it appears to float firmly anchors it with an archaic dignity.

The other chalice (Pl. 68) is an astonishing example of the daring sculptural elements Payne Bowles brought to ritual vessels. Form is radically distorted to interact with space, light, and shadow. But despite the agitated quality of her forms, Payne Bowles always maintains a clear sense of the elements: sheet, rod, and wire retain their unique character and properties. In this and later chalices, traditionally solid elements such as handles and pedestals are punctured with voids or cavities. Elements wrap, encircle, frame, penetrate, and enclose space. Hollows become important with negative space active in the overall arrangement. Allowing no rest for the eye, the play of light and shadow—moving in, out, and over changes of shape and texture—is constantly agitated and evanescent, but nonetheless it resolves formal harmonies of balance and proportion. The arresting and numinous quality of these chalices is a result of this tension between resolved composition and fractured form and surface.

A jagged-handle fork with overlapping triangles (Pl. 66) displays the ornamental style of synthetic cubism, a fashion evoking modernism that came to consumer goods after 1925. The novelty aroused heated controversy for or against

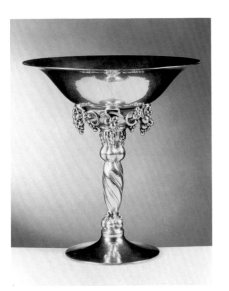

Fig. 20. Bowl by Georg Jensen (design introduced 1918). Newark Museum, Newark, N.J. (acc. no. 22.43).

modern art. A modernist outlook was implicit with Janet Payne Bowles; a similar passage of overlapping triangles is seen in the base of a previously discussed chalice (Pl. 68).

Sheet or ribbonlike stock, angular snips, and overlapping joints in the fork and chalice are also found in a group of rings (cat. nos. 110, 112, 113) that probably date from the same time. A matte mottled surface similar to the handle of Payne Bowles's reliquary (Pl. 69) is also used to contrast with the reflective surface of spheres and applied wire of two other rings (cat. nos. 108, 117). Another ring (cat. no. 116) vaguely recalls the lily finial on the reliquary; and yet another ring (cat. no. 111) is made of square-section rod, flat ribbon curls, and twisted wire, as seen in the aforementioned chalice (Pl. 68).

Payne Bowles's evolution in working techniques may have been partly influenced by her school's new facility and the improved equipment in use after December 1928.[74] Her working process is illuminated by a ceramic pitcher (Pl. 70) probably made at the time she took over her school's pottery classes. Its apparent built-up composition reveals her self-generative flow of creative engagement with materials. One of Payne Bowles's students, a member of her pottery classes from their beginning in 1929 to 1932, recalled her teacher's first attempts at making pots by the coil method. They were "original, creative, but looked like they were soldered."[75] That Payne Bowles was consistent in her creative approach from one medium to another underscores that in her work she was not so much making objects as giving form to her emotions.

The intuitive judgment Payne Bowles used in creating her work she also exercised daily with her students and, over time, to modify her own earlier efforts. Payne Bowles "evolved" pieces rather than made them; objects went through a period of "fermentation" and were reworked over the years. A student noted that "she had work that took her two and three years at a time to make. She'd put them down until she got inspired and then she'd pick that piece up and work on it."[76] She made subtle modifications rather than dramatic alterations; hers was a process of successive distillations.

Conclusion

The keynote of the modern movement in art is the expression of one's inner self.
Arthur Jerome Eddy[77]

Janet Payne Bowles was not just a beater of metal who through repeated hammer blows would move and coax material into a desired shape with a refined surface finish, whose visible hammer marks gave evidence of handcraft and human imprint. Metal was suited to Payne Bowles's needs because of its ability to be readily rearranged to a rich variety of effects. The additive aspect of her work clearly records her actions. It conveys a sense of the process, the activity of hands, and a special communion of the artist with the materials and natural forces. And while her work can give the impression of being crude or haphazard, it is consistently substantial, disciplined in its construction, refined in soldering and finish, and resolved in terms of harmony, balance, and proportion. Her forms

Fig. 21. Silver-gilt cup and cover with chrysoprase bowl, German, in the manner of Ludwig Krug of Nurnberg, ca. 1520. Iparmuveszeti Museum, Budapest.

were chosen for their allegorical power and as the vehicle or construct with which to work out her ideas. Undiluted by preliminary drawings or models, Payne Bowles's work resulted directly from a creative engagement and exploitation of the materials' inherent expressive properties, not out of a need to demonstrate technical authority.

Payne Bowles's teaching position afforded her the freedom to work on her own without the constraints, typical of studio metalsmiths and jewelers, of practicing serial production for an ongoing patronage or the necessity of maintaining or working with a staff. Payne Bowles believed in art as a spontaneous individual activity, and such practices did not satisfy her need for a fully personal expression.

Although it is certain that Payne Bowles received commissions from Maude Adams and won an award for her work at the Panama-Pacific International Exposition, her commissions from other illustrious patrons such as J. Pierpont Morgan, as well as awards for international competitions, cannot be confirmed. It seems likely that Payne Bowles invented commissions and awards, and that she did this not as a deception but as an "enabling" fiction. These acts reordered reality to serve her needs as an artist, to mark a point of departure for her work, and to identify an audience for her to reach.[78]

Payne Bowles's career paralleled the Arts and Crafts movement's interest in revitalizing culture through reforms in taste, design, and production methods, but also the modern art movement's interest in spirituality and the forceful expression of inner feeling and emotion. Seeking an expression unhampered by academic canons, she was drawn to Celtic and medieval art and allied herself with their symbols and intensity of feeling and belief. She sought to embrace the psychology of art, and her work exemplifies the modernist urge to experiment on an emotional, intuitive basis. Her explorations took her beyond conventional limits in metalsmithing techniques and the interpretation of form. Form resulted from emotion, and the extraction of the essence of emotion became Payne Bowles's preoccupation. With metalwork, she sought to awaken the imagination to a spiritual emotional response and to "express the universal and eternal." What she did produce are among the most unusual and expressive examples of early twentieth-century American metalcraft and jewelry.

PLATE 10

Server
ca. 1921-24
cat. 101

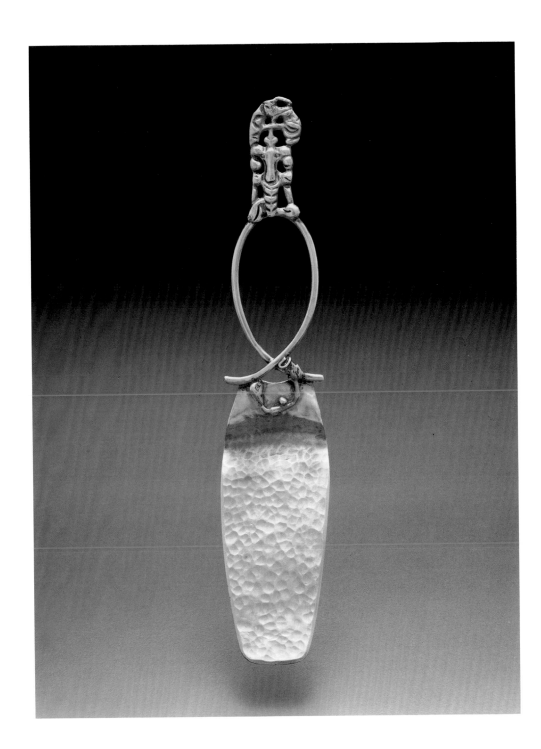

The author would like to thank the following for their insights: Helen Cooper, Robin J. Frank, and Susan B. Matheson, Yale University Art Gallery, New Haven, Connecticut; Susan Fillin Yeh, Reed College Gallery, Portland, Oregon; and John R. Fix, Norwich Free Academy, Norwich, Connecticut.

Notes

1. Sikorski, p. 23, n. 29. He dates the essay to 1935. Payne Bowles presented "The Step-Off" as a lecture in Indianapolis in 1939.

2. A coffeepot (which had been worked on by Payne Bowles) was given by Mira Bowles to Jerome Sikorski, from whom it was acquired by the Indianapolis Museum of Art in 1992 (Pl. 6).

3. See Sikorski, pls. 9-12.

4. Bowles 1904, p. 64.

5. See Kaplan, pp. 158, 280-83, 287-89.

6. See especially the essay by Neil Harris, "Selling National Culture: Ireland at the World's Columbian Exposition," pp. 82-105.

7. For cultural meaning in Celtic art, see Michael Camille, "Domesticating the Dragon: The Rediscovery, Reproduction, and Re-Invention of Early Irish Metalwork," in Edelstein, esp. pp. 6, 9. For American spiritual awareness at the turn of the century and the ideas of William James, see Lears, esp. pp. 142, 149, 161.

8. Rogers work first appeared in Joseph Bowles's *Modern Art* for the Spring of 1893. For Morris's influence on Rogers through Bowles, see Thompson, pp. 55-67. See also Buffalo 1900, p. 50, no. 628.

9. See Boston 1899, p. 59, pl. 22; and Pond, p. 98.

10. Two editions were published: fifty copies on parchment and another fifteen copies on English handmade paper. Two copies of the parchment edition are in the collection of Janet Payne Bowles's great-grandnieces Tina and Nicola Remshardt of Coburg, Germany; a third copy on English paper was presented by Payne Bowles to Helen McKay Steele in 1902 and remains with the Steele family (see Pl. 2); and a fourth copy on parchment is in the collection of the Indianapolis Museum of Art (acc. no. 81.785).

11. See Gombrich, figs. 32, 82.

12. See Thompson, pp. 62, 65, pl. 26, where she attributes this book's illuminations to Rogers.

13. See the letter from J. M. Bowles to F. A. Whiting, March 22, 1910, in the Whiting papers, Archives of American Art, Washington, D.C., roll 429, frame 655.

14. See Boston 1899, p. 27, no. 103; Chicago 1899, pp. 120, 134; and New York 1899. Payne Bowles may also have received encouragement from Indianapolis artist Brandt Steele, who made and exhibited base metalwares early in the century.

15. See the essays by Shifman and Darling in this catalogue for more on Payne Bowles's training. See also Brenton, p. 7; and Buschmann, p. 18.

16. Stewart, p. 14.

17. *Ibid.*

18. "Arts and Crafts Organize," *New York Times*, Apr. 28, 1906, magazine section, p. 11.

19. Kohlman 1924, p. 55.

20. Highly skilled as an artist metalsmith, Okabe formerly had been an assistant to Kakuzo Okakura in the Department of Chinese and Japanese Art at the Museum of Fine Arts, Boston. See New York, The Metropolitan Museum of Art, p. 99.

21. See "A Collection of Copper and Brass," *House Beautiful* 7 (Jan. 1900), pp. 68-71; Samuel Howe, "The Drake Collection of Brass and Copper Vessels," *The Craftsman* 2 (May 1902), pp. 73-79; and "Art School Notes," *Art Interchange* 46 (June 1901), p. 145.

22. Stromböm, pp. 68-69, no. 68; see also "Zoomorphics," in Bain, pp. 101-17.

23. Letter in the Whiting papers (note 13).

24. "Maude Adams to Use Real Silver 'Props,'" *Chicago Tribune*, June 5, 1910, sect. 9. The paper also noted: "Mrs. Bowles has designed in silver an arch-bishop's crozier for use in 'The Canterbury Pilgrims,' which the Coburn players are to give at the White House grounds this month at Mrs. Taft's request."

25. See "Maude Adams to Use Weapon," clipping in the Janet Payne Bowles Archives, Indianapolis Museum of Art.

26. Bowles 1910, pp. 309-20; and Bowles 1911, pp. 109, 111.

27. Bowles 1910, p. 316.

28. Fosdick, "The Fourth Annual ...," p. LXXXI. For other reviews, see Fosdick, "American Handicraft," p. 102; and "Fourth Annual Exhibition...," *Jewelers' Circular Weekly* 61 (Dec. 21, 1910), p. 63.

29. See the buckle in Kohlman 1924, p. 56, where it is mistakenly captioned as gold.

30. Rathbone, p. 201, fig. 70; additional Roman precedent for the chain is seen in Marshall, pl. LVII, no. 2723.

31. Richard H. Randall, Jr., "Migration Jewelry," in Baltimore and New York, no. 91; see also Marshall, pl. LV, nos. 2668-69.

32. For Roman key rings, see Oman, p. 58, pl. VI, nos. 166, 172.

33. Buschmann, p. 18.

34. Dow 1913, p. 38.

35. Kohlman 1924, pp. 54-55.

36. *Shortridge Daily Echo* (hereafter *SDE*), Oct. 4, 1912, p. 3; Feb. 13, 1913, p. 1.

37. *SDE*, Apr. 11, 1912, p. 1; Indianapolis, John Herron Art Institute, *Catalogue of the Fifth Annual...* (1912), nos. 176-78.

38. *Indianapolis News*, May 10, 1913, and Dec. 13, 1913, from the Indianapolis Museum of Art Publicity Notebook for 1912; *SDE*, Sep. 24, 1914, p. 4; *Indiana Daily Times*, Sept. 22, 1917, p. 7. In 1920 Payne Bowles stated, "He (Clarke) introduced me to Mr. Morgan and for four years I did nothing but pieces for his collection."; see *Indiana Daily Times*, Nov. 29, 1920, p. 9.

39. Kohlman 1924, p. 57.

40. *Indiana Daily Times*, Sept. 22, 1917, p. 7.

41. See Strong, pls. 22A, 67C. Additional examples are cited by Jessup, pp. 99-100, 126-28, fig. VI, no. 9, fig. XXXIII, who notes that some slender-stemmed silver spoons were not for ordinary domestic use, but worn by women, usually attached by rings to the girdle.

42. Kohlman 1924, p. 55.

43. In addition to the illustration, the newspaper added: "She prefers to work with gold, but the Paris prize was won with a dull silver, handcarved jewel box." See *Indiana Daily Times*, Sept. 22, 1917, p. 7. A photograph from the Janet Payne Bowles Archives of the same view, annotated "Jewel Box carved gold 6" long 3" high made for J. Pierpont Morgan Sr.," suggests the box may date from about 1913. Official documentation of Payne Bowles's participation in the Panama-Pacific International Exposition of 1915 is recorded in a catalogue of the exhibition, and in Payne Bowles's own hand on a certification of a bronze medal for her exhibits, where she described her submissions as: "Three necklaces (gold and silver); one belt pin (silver); one jewel box." No annotated photographs exist of what Payne Bowles exhibited. See *Official Catalogue of Exhibitors, Panama-Pacific International Exposition* (San Francisco, 1915), p. 74. The document for the award is dated May 6, 1915, and is in the Janet Payne Bowles Archives.

44. See *Indianapolis Star*, Jan. 28, 1921, p. 16; see also Keystone Special Correspondent (Indianapolis), *The Keystone* 48 (Mar. 1921), p. 253; and *American Art Annual* 27 (1930), p. 511.

45. See Kohlman 1924, pp. 55-57. Close comparison of the illustrated pot and the museum's pot show them to be the same.

46. *The Craftsman* illustration is reproduced in Stephen Gray and Robert Edwards, eds., *Collected Works of Gustav Stickley* (New York, 1981), p. 29; see also *Gift and Art Shop* 4 (Apr. 1921), pp. 23, 58; 6 (Mar. 1922), p. 129; 10 (Apr. 1924), pp. 50, 52, 149.

47. For "Blossom" flatware, see Washington, D.C., Smithsonian Institution, no. 71. The Jensen exhibition at the Art Institute of Chicago opened on January 14, 1921: see Chicago, Art Institute of Chicago, *Bulletin*... 15, no. 2 (Feb. 1921), p. 127. An added reason for Payne Bowles to journey to Chicago would have been to deliver her work for exhibition at the Art Institute on March 8: see Chicago, Art Institute of Chicago, *Catalogue*... (1921), nos. 559-61.

48. See Indianapolis, John Herron Art Institute, *Catalogue of the Fourteenth Annual*... (1921), no. 146.

49. For the Jensen jam spoon, see Washington, D.C., Smithsonian Institution, no. 74.

50. Kohlman 1924, pp. 54-55; Indianapolis, John Herron Art Institute, *Catalogue of the Nineteenth Annual Exhibition*... (1926), no. 144. Photographs of the 1926 and 1929 exhibitions are in the Janet Payne Bowles Archives.

51. See Nielsen, p. 21; and Mourey, p. 209.

52. Brenton, p. 7. In 1922 it was said that she kept wire and pliers in her handbag to explore something new at opportune moments.

53. See "A New Metal," p. 65. For Bowles's use of "cupra," see "Metal Work By Mrs. Bowles," p. 2. See also "Neuman's 1931 Inventory" in the Janet Payne Bowles Archives.

54. For the best Dow reference, see Moffatt.

55. See Boston 1899, p. 11, no. 10c. Joseph Bowles also commissioned Dow to design a woodcut for the cover of his magazine, *Modern Art*. The cover was widely publicized when it was used as a poster to promote the periodical. See Moffatt, p. 111.

56. See Moffatt, p. 132. As a teacher, Dow influenced such well-known artists as Georgia O'Keeffe and Max Weber.

57. See "Sixth Annual Convention," *Art & Progress* 6 (May 1915), p. 325.

58. Dow 1899, p. 3.

59. Kohlman 1924, p. 55.

60. See Grace Ferguson Haugh, Arthur Ellis, and Frank Lobraico, transcript of Janet Payne Bowles oral history session, Indianapolis Museum of Art, April 24, 1991, pp. 7, 9-10, 12, 21-22, 25.

61. Dow, "Talks on Art Appreciation," *The Delineator* 86 (Jan. 1915), p. 15; (Apr. 1915), p. 15; (July 1915), p. 15; (Feb. 1916), pp. 15-16. For the Bowles classes, see *SDE*, Dec. 1, 1932, p. 4.

62. See Tarbell, "Direct Carving," in Marter, Tarbell, and Wechsler, pp. 45-66. See also Chicago, Art Institute of Chicago, *Catalogue*... (1924), nos. 61, 112.

63. *SDE*, Apr. 6, 1920, p. 4.

64. Kohlman 1924, p. 54.

65. See Alice M. Sharkey, "Art Center Notes," *Bulletin of the Art Center, New York* 3 (Dec. 1924), p. 93; (Jan. 1925), p. 123. See also "Metal Work by Mrs. Bowles," p. 13.

66. Kandinsky, p. 35.

67. Payne Bowles visited Florence in March 1926; see *SDE*, Sept. 15, 1926, p. 1; for the church, see *SDE*, Mar. 8, 1927, p. 4.

68. An early view of the comb, captioned "Repoussé hair ornament in gold," was published after it was incorporated into the font; see Buschmann, p. 18.

69. See the illustration of a frog in "Prehistoric American Motifs...," *Jewelers' Circular Weekly*, July 5, 1911, pp. 55-56. For the photographs, see *SDE*, Jan. 6, 1926, pp. 1, 4. Payne Bowles made annual summer trips to Europe from 1925 to 1928 that included trips to Russia in 1927 and 1928; and in 1933 she spent her summer "vacation traveling in South America and studying the Incas and Mayan civilization." See *SDE*, Sept. 13, 1933, pp. 1, 4.

70. Nielsen, pp. 7, 15. For more recent references, see the pedestal bowl in Washington, D.C., Smithsonian Institution, no. 68; and the jardiniere in MacFadden, p. 98, no. 88.

71. See Futurist artist Umberto Boccioni's 1912 sculpture "Development of a Bottle in Space," in *Pioneers of Modern Sculpture* (London, 1975), p. 40. Payne Bowles saw an exhibition of the Futurists in New York during her Christmas vacation in 1923; see *SDE*, Jan. 8, 1924, p. 1.

72. For the chalice or salt stand (cat. no. 107) see "Teacher's Jewelry Craft Work," *Indianapolis Star* (Dec. 21, 1930), alco-gravure section and a photograph annotated, "Salt Stand, October 1930," Janet Payne Bowles Archives. A "chalice large, four posts on base" was one of four chalices Payne Bowles recorded in 1931; see "Neuman's 1931 inventory," Janet Payne Bowles Archives.

73. See Hayward, nos. 269, 270, 473, 474.

74. See *SDE*, Nov. 22, 1928, p. 1.

75. Telephone conversation between Grace Ferguson Haugh and Barry Shifman, associate curator of decorative arts, Indianapolis Museum of Art, Nov. 23, 1990.

76. Frank Lobraico (see note 60), pp. 33, 38.

77. Arthur Jerome Eddy, *Cubists and Post-Impressionism* (Chicago, 1914), p. 122, as quoted in Yeh, p. 70.

78. As work (said by Payne Bowles to be commissioned) accumulated over time, she may have come to think of it as studies for the "commissions." Reporting on an exhibition of teachers' work in 1922 the *SDE* added, "Mrs. Bowles will have some silver studies of the Morgan collection . . . there"; see "Art Notes," *SDE*, Oct. 13, 1922.

PLATE 11

Pendant with chain
ca. 1907-11
cat. 2

PLATE 12

Pendant with chain
ca. 1907-11
cat. 4

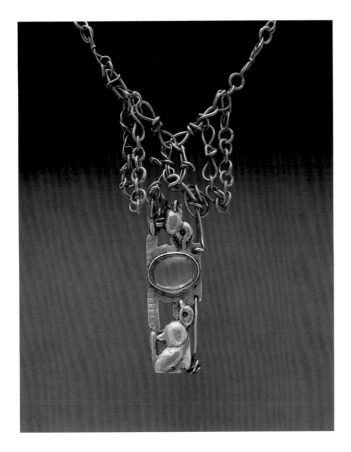

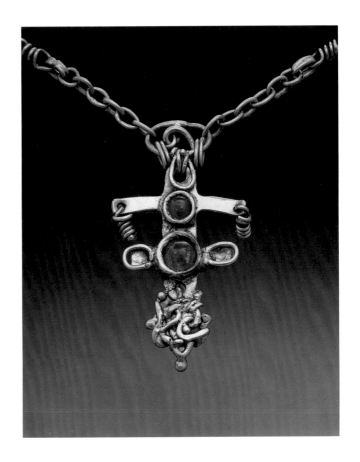

PLATE 13

Pendant
ca. 1907-11
cat. 5

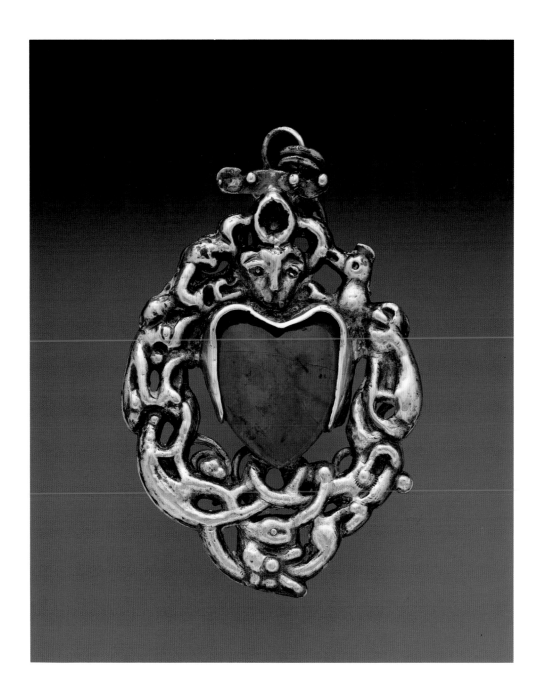

PLATE 14

PLATE 15

Belt clasp/pendant
ca. 1907-11
cat. 6

Pendant
ca. 1907-11
cat. 8

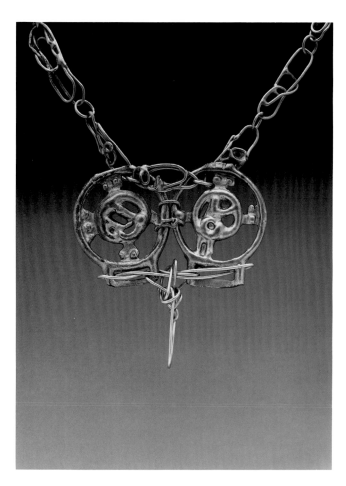

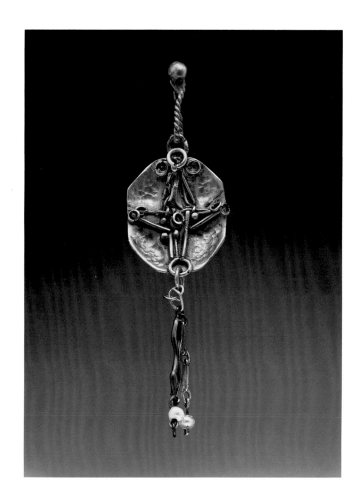

PLATE 16

Ring
ca. 1907-11
cat. 7

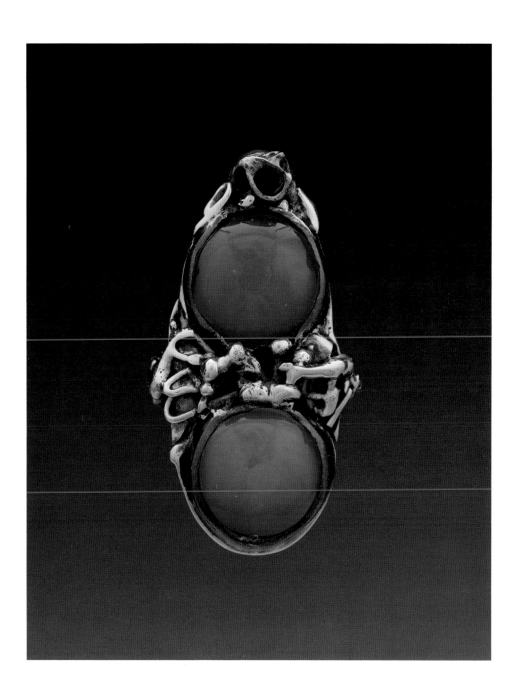

PLATE 17

Pendant with chain
ca. 1910-12
cat. 9

PLATE 18

Pendant with chain
ca. 1910-12
cat. 10

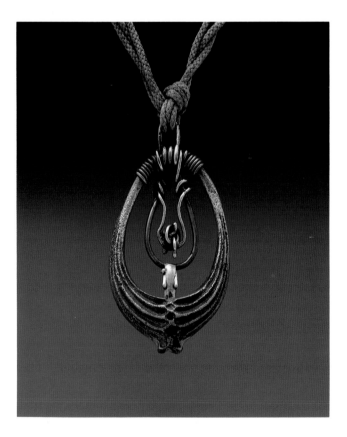

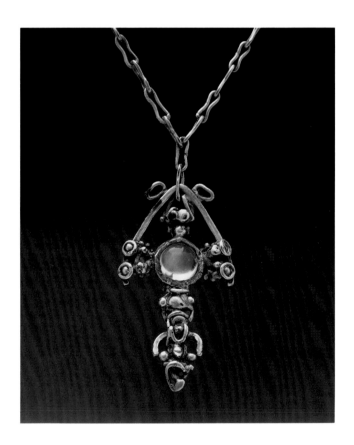

PLATE 19

Pendant with chain
ca. 1910-12
cat. 13

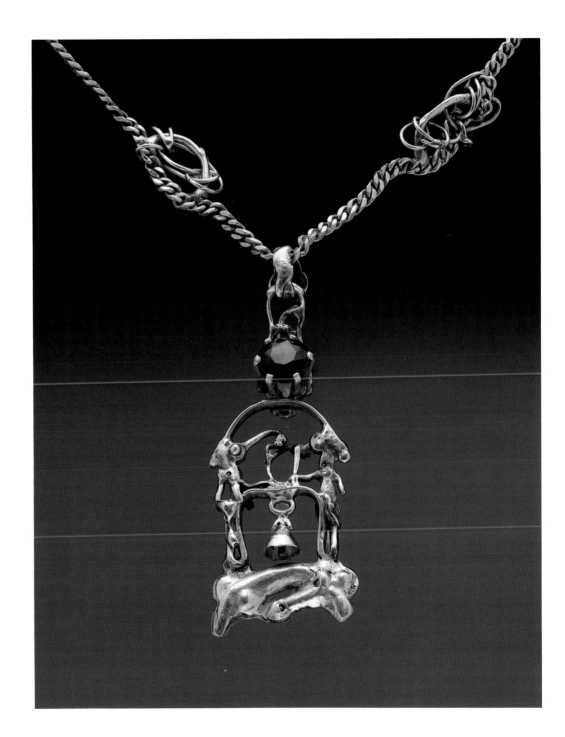

PLATE 20

Ring
ca. 1910-12
cat. 11

PLATE 21

Ring
ca. 1910-12
cat. 12

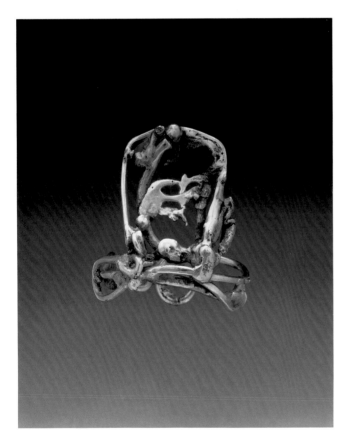

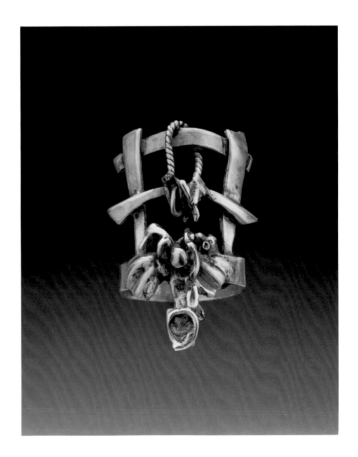

PLATE 22

Ring
ca. 1912-15
cat. 19

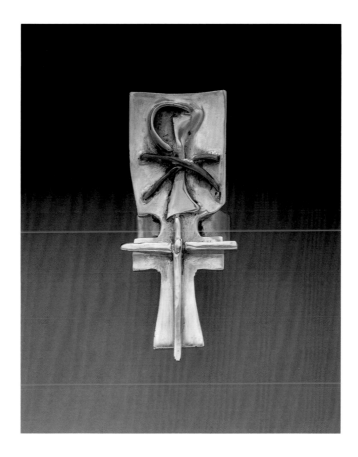

PLATE 23

Spoon
ca. 1912-15
cat. 16

PLATE 24

Spoon
ca. 1912-15
cat. 28

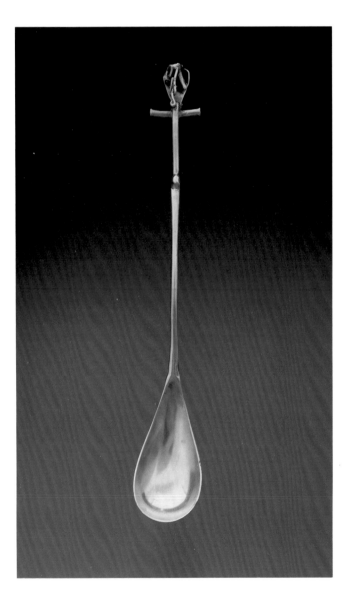

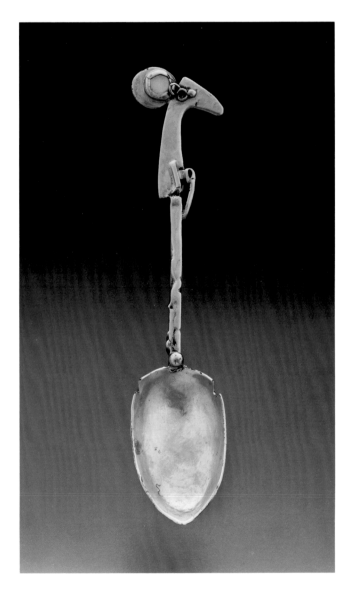

PLATE 25

Spoon
ca. 1912-15
cat. 32

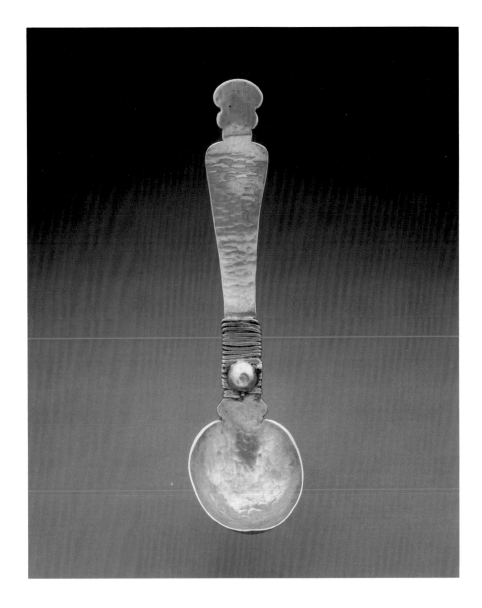

PLATE 26

PLATE 27

Spoon
ca. 1912-15
cat. 33

Spoon
ca. 1912-15
cat. 34

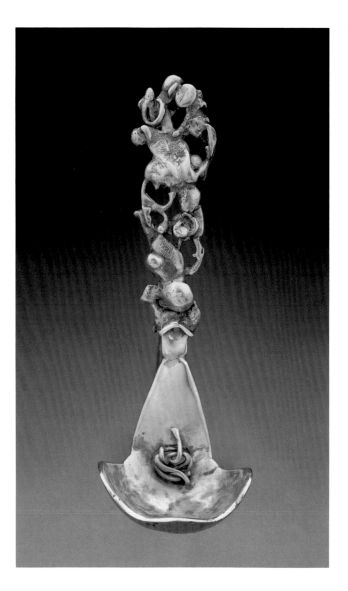

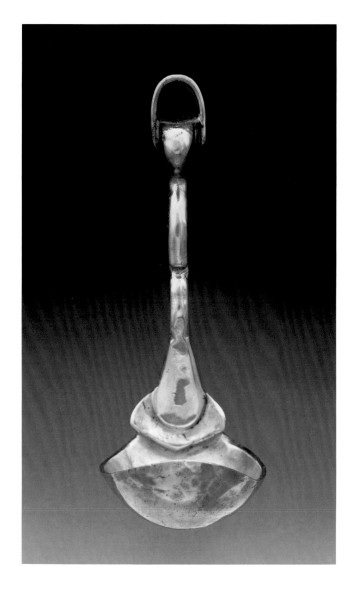

PLATE 28

Spoon
ca. 1912-15
cat. 35

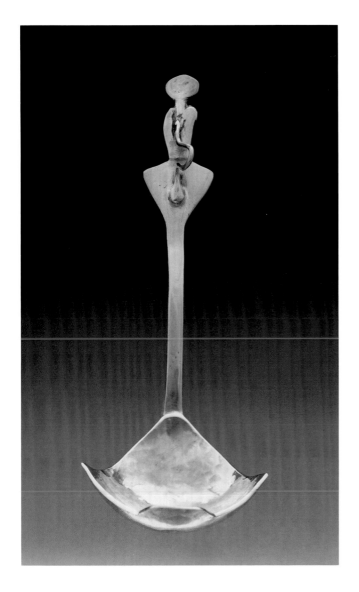

PLATE 29

Spoon
ca. 1912-15
cat. 36

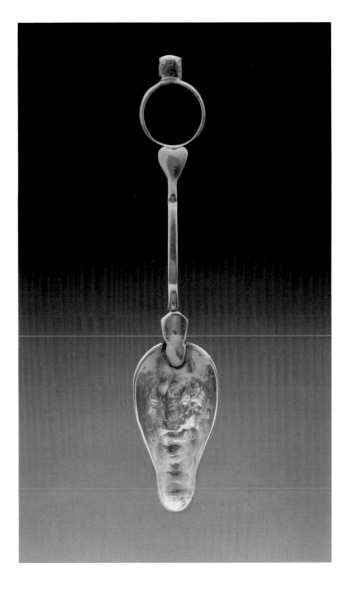

PLATE 30

Brooch
ca. 1912-15
cat. 37

PLATE 31

Stick pin/pendant
ca. 1912-15
cat. 38

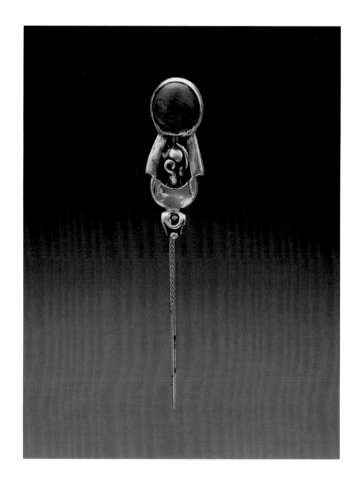

PLATE 32

Pendant
ca. 1912-15
cat. 40

PLATE 33

Pendant
ca. 1912-15
cat. 42

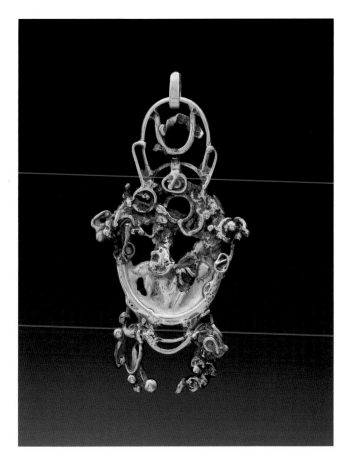

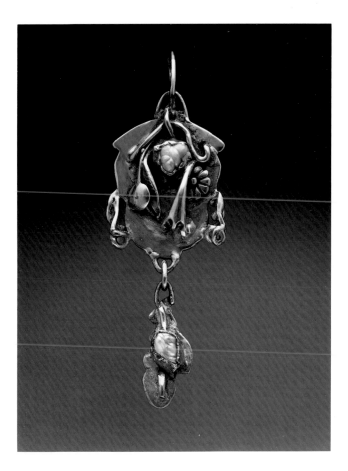

PLATE 34

Spoon
ca. 1912-15
cat. 43

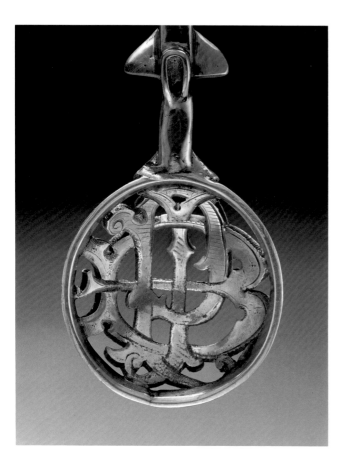

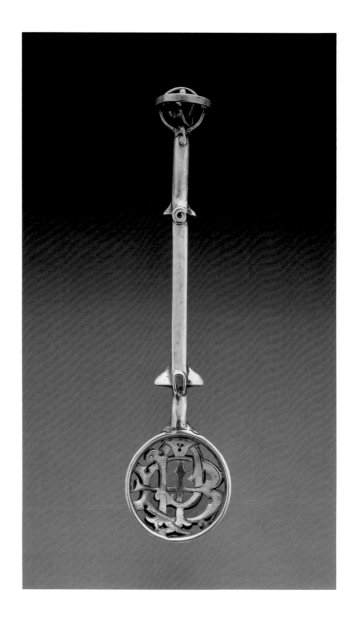

PLATE 35

PLATE 36

Spoon
ca. 1912-15
cat. 44

Spoon
ca. 1912-15
cat. 45

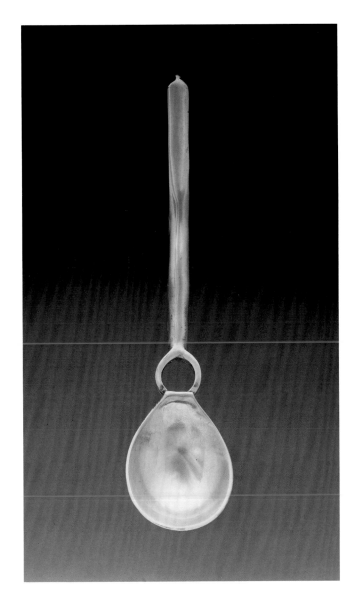

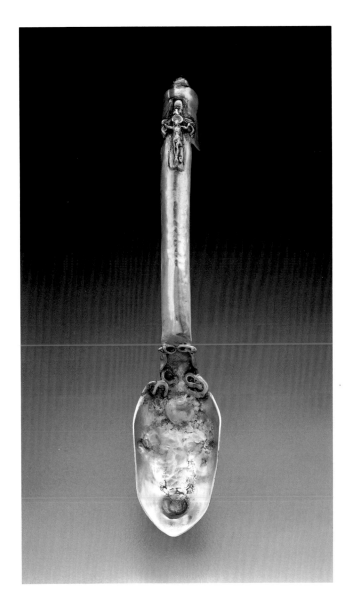

PLATE 37

Pendant
ca. 1912-15
cat. 47

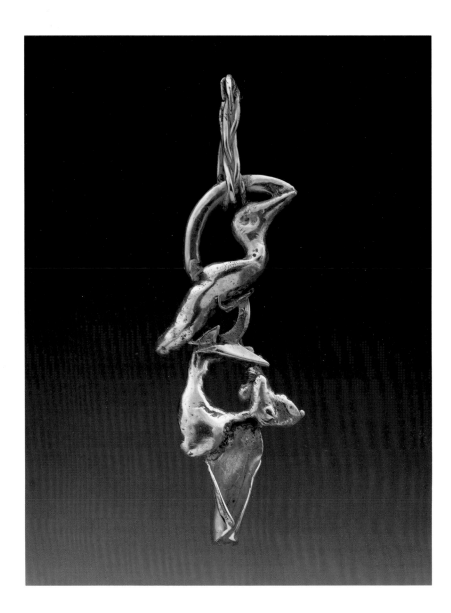

PLATE 38

Pectoral cross
ca. 1912-15
cat. 48

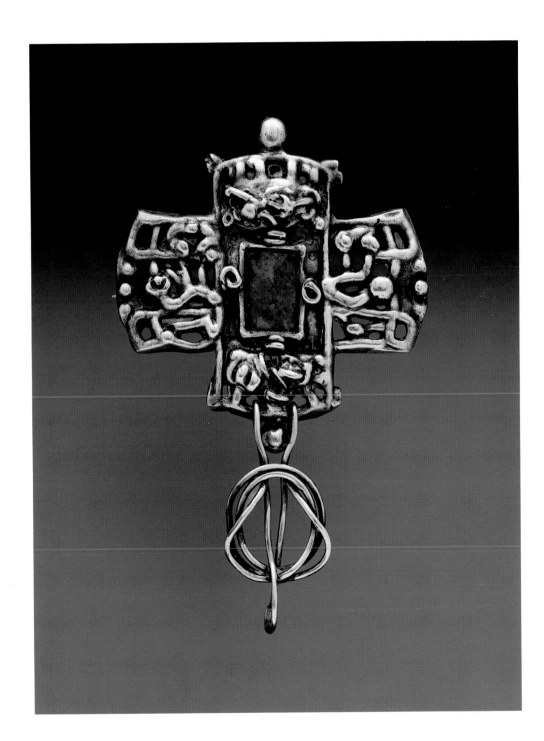

PLATE 39

Box
ca. 1913
cat. 50

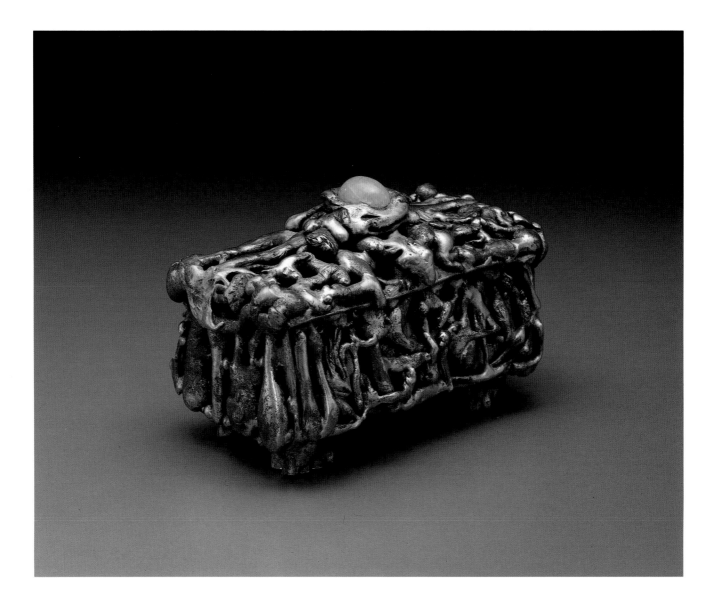

PLATE 40

Box
ca. 1913
cat. 51

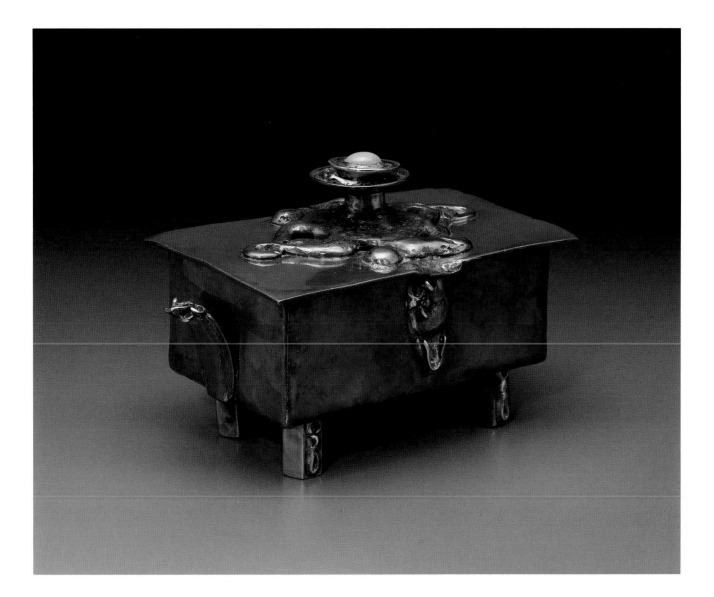

PLATE 41

Spoon
ca. 1915-20
cat. 53

PLATE 42

Spoon
ca. 1915-20
cat. 54

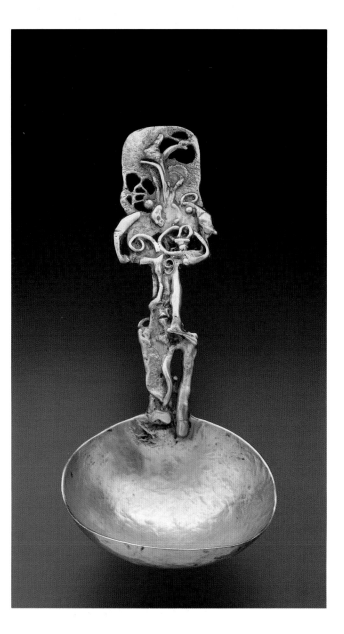

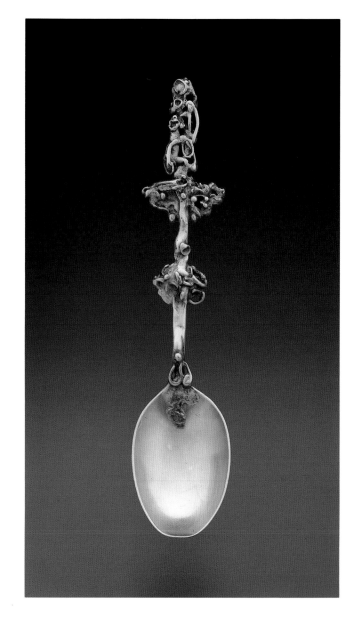

Ladle
ca. 1916-19
cat. 55

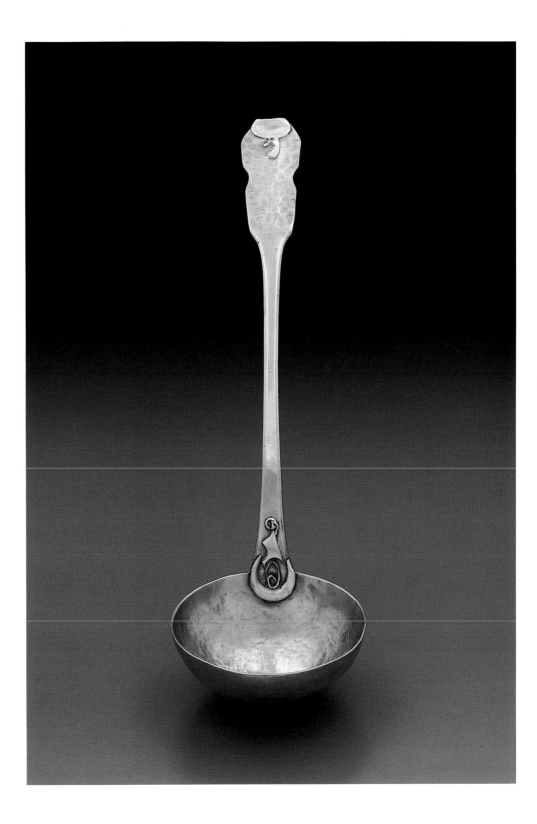

PLATE 44

Chalice
ca. 1916-20
cat. 56

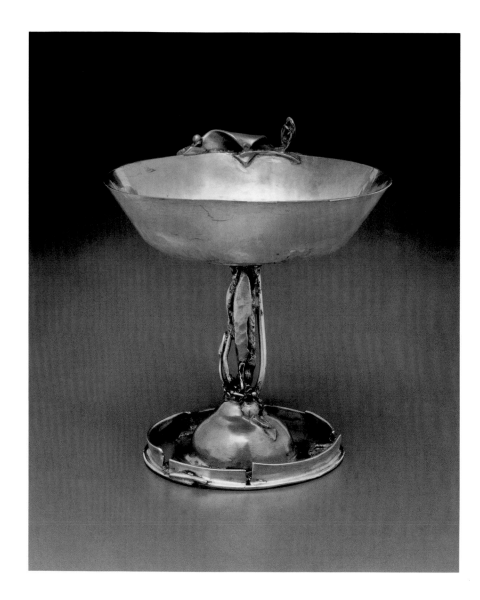

PLATE 45

PLATE 46

Spoon
ca. 1916-20
cat. 57

Spoon
ca. 1916-20
cat. 58

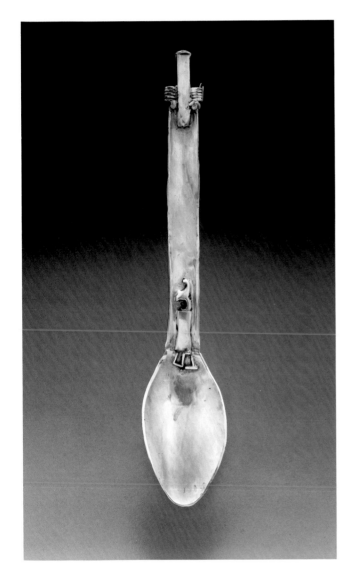

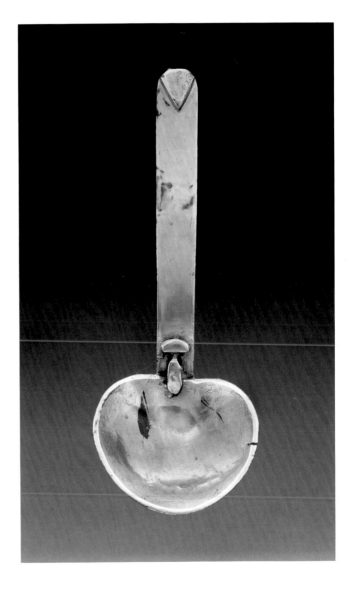

Spoon
ca. 1916-20
cat. 68

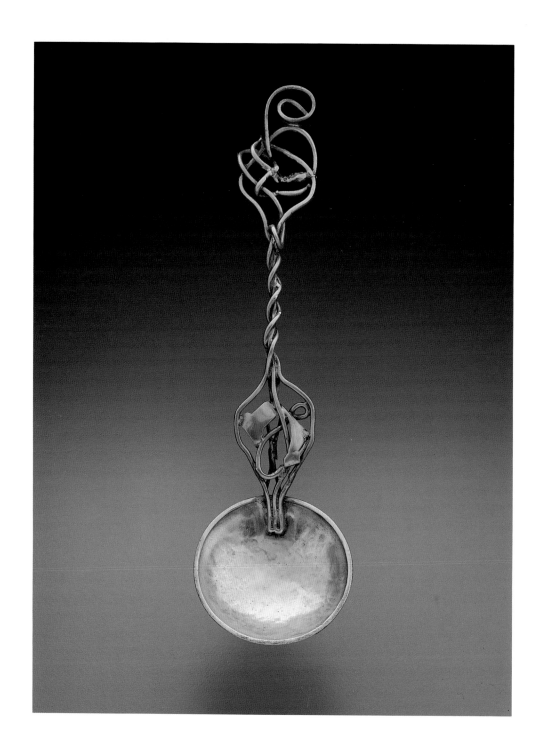

PLATE 48

Spoon
ca. 1916-20
cat. 69

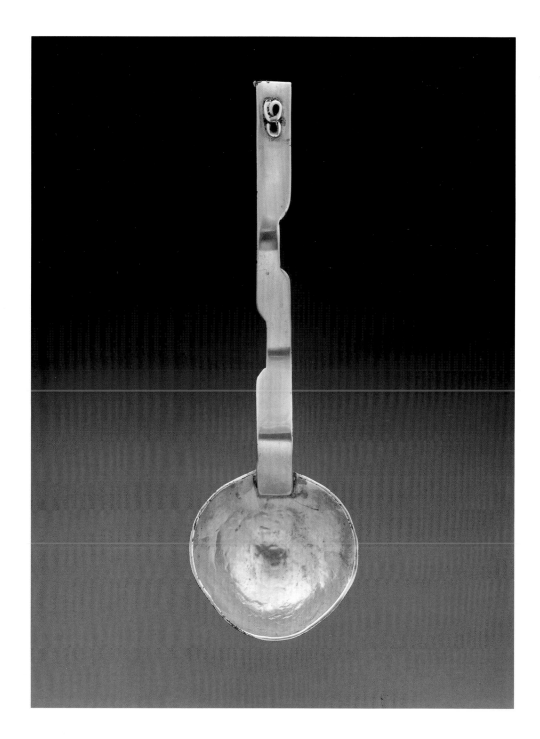

PLATE 49

Ring
ca. 1916-20
cat. 64

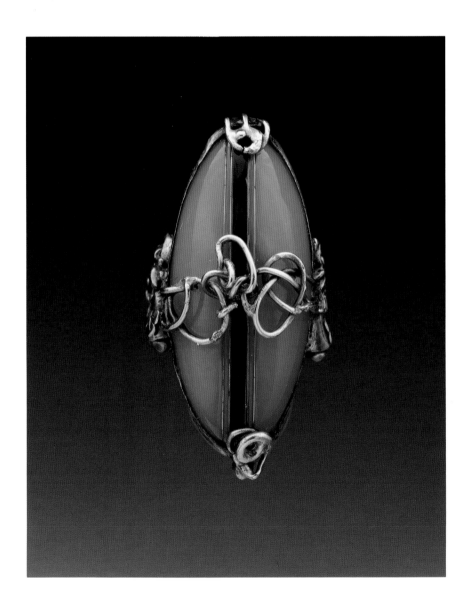

PLATE 50

Ring
ca. 1916-31
cat. 79

PLATE 51

Ring
ca. 1916-31
cat. 80

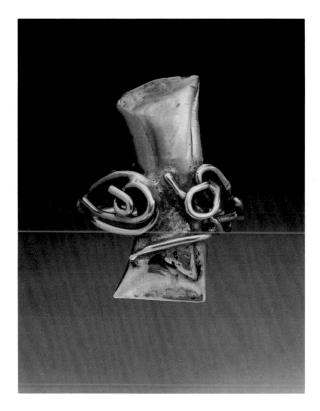

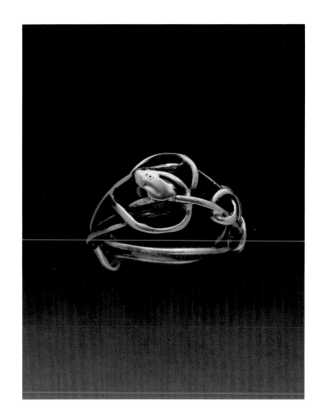

PLATE 52

Chalice
ca. 1921-23
cat. 82

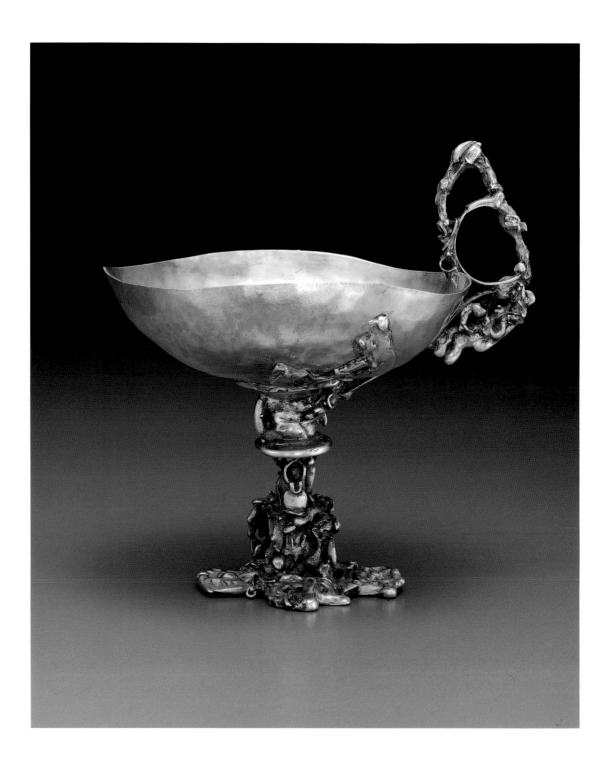

PLATE 53

PLATE 54

Ladle
ca. 1921-24
cat. 85

Spoon
ca. 1921-24
cat. 87

PLATE 55

Ring
ca. 1921-24
cat. 88

PLATE 56

Ring
ca. 1921-24
cat. 95

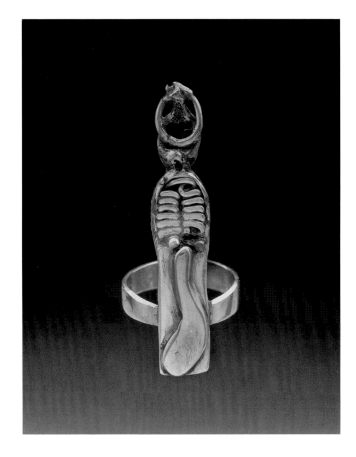

PLATE 57

Ring
ca. 1921-24
cat. 96

PLATE 58

Ring
ca. 1921-24
cat. 100

PLATE 59

———————————

Spoon
ca. 1921-24
cat. 91

PLATE 60

———————————

Spatula
ca. 1921-24
cat. 93

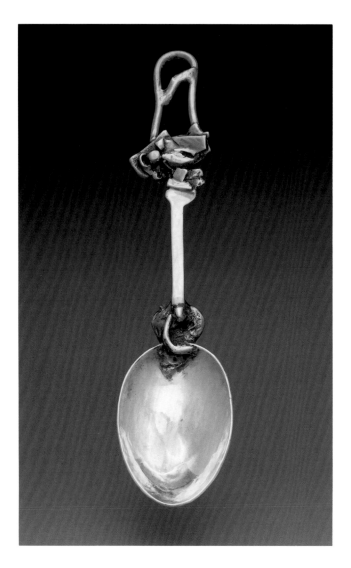

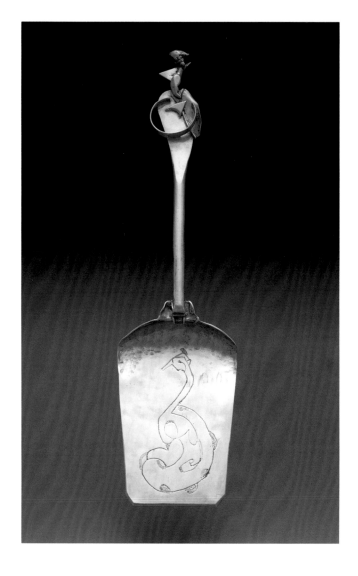

PLATE 61

Butter knife
ca. 1921-24
cat. 97

PLATE 62

Fork
ca. 1921-24
cat. 98

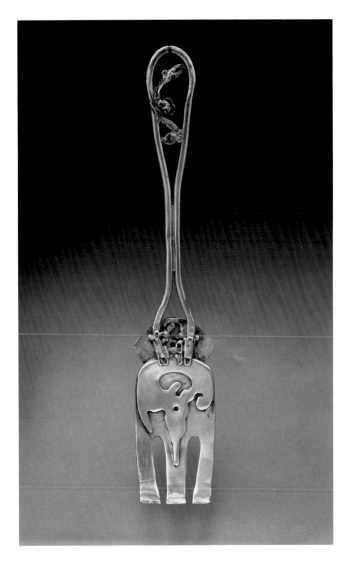

PLATE 63

Ring
ca. 1925-26
cat. 102

PLATE 64

Pendant
ca. 1925-31
cat. 115

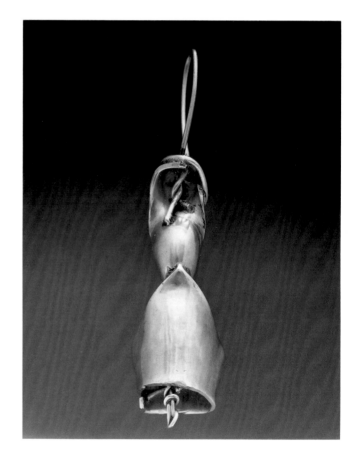

PLATE 65

PLATE 66

Spoon
ca. 1925-31
cat. 120

Fork
ca. 1925-31
cat. 121

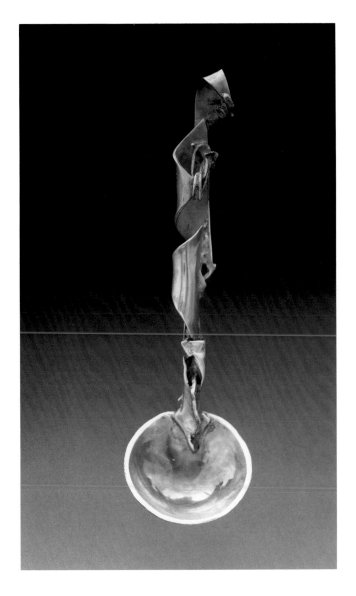

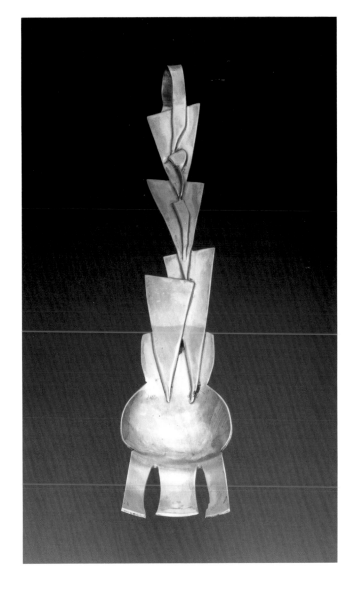

PLATE 67

Chalice or salt stand
ca. 1925-30
cat. 107

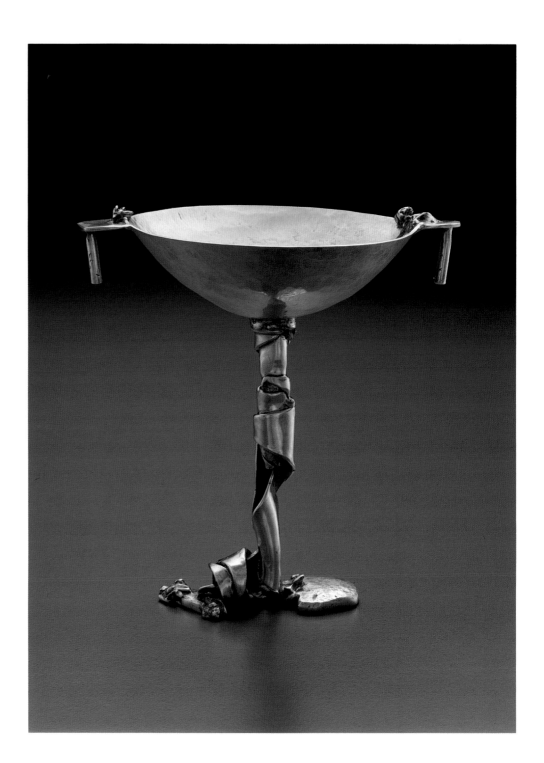

PLATE 68

Chalice
ca. 1925-31
cat. 123

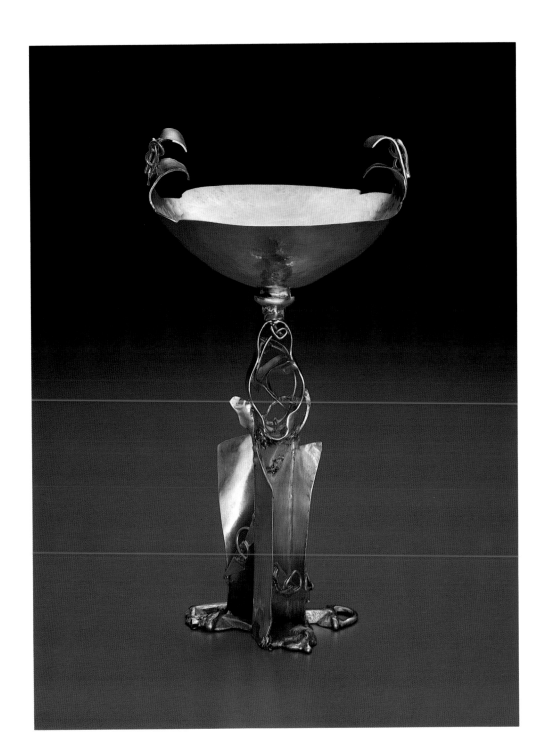

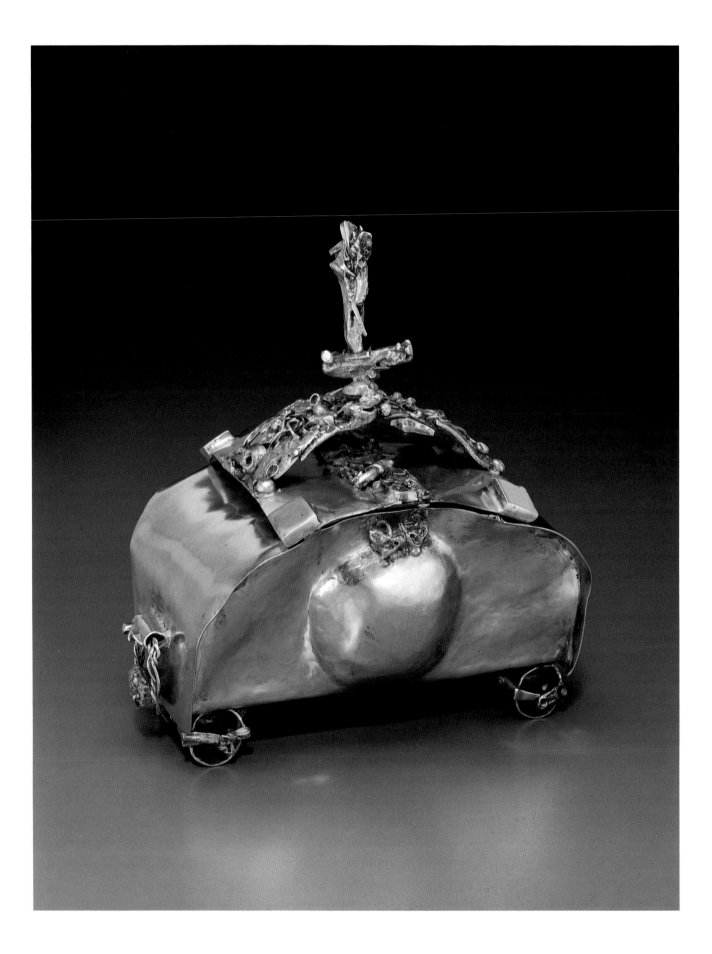

Chronology

1872/73	Born June 29 in Indianapolis to Mary and John Payne
1890	Graduates from Indianapolis (later renamed Shortridge) High School
	Visits Boston and studies piano with Edward MacDowell
1894	Becomes a member of the Portfolio Club in Indianapolis
1895	Marries Joseph Moore Bowles
	Moves to Boston
	Begins attending lectures by William James at Radcliffe
1896	Publishes book reviews of Cecilia Waern's *John La Farge, Artist and Writer* and Charles Hiatt's *Pictures and Posters* in *Modern Art*
1897	Publishes a book review of Richard Muter's *A History of Modern Painting* in *Modern Art*
1899	Exhibits book illuminations at *Second Exhibition of the Society of Arts and Crafts*, Copley Hall, Boston, April 4-15
1900	Begins working in metals, especially gold and silver
1901	Creates book illuminations for *The Second Epistle of John*
	Exhibits book illuminations at *Arts and Crafts Exhibition at the Providence Art Club*, Providence, Rhode Island
1902	Bowleses move to Rye, New York
	Daughter, Mira, born July 8
1904	Bowleses move to New York City
	Publishes "Artistic Dress for Children" in *The Craftsman*
	Son, Jan, born November 2
1905-06	Bowleses live at artists' colony in Leonia, New Jersey
1906	Bowleses move to Upton Sinclair's Helicon Hall
1907	Returns to New York City after fire at Helicon Hall, March
	Opens own jewelry and metalwork shop at her husband's office in New York
1908	Visits The Metropolitan Museum of Art and observes Japanese metalworkers

Plate 69. *Reliquary*, ca. 1926-27 (cat. 124)

1909	Receives commissions from stage actress Maude Adams; Charles Coburn; Sir Caspar Purdon Clark, director of The Metropolitan Museum of Art; and J. Pierpont Morgan
	Publishes "A Situation in Craft Jewelry" for *Handicraft*
1910	Exhibits metalwork and jewelry at *Fourth Annual Exhibition of the National Society of Craftsmen*, New York, December
1912	Separates from husband and returns to Indianapolis with her children
	Begins teaching art metal and jewelry classes at Shortridge High School
	Exhibits metalwork and jewelry at *Fifth Annual Exhibition of Works by Indiana Artists*, John Herron Art Institute, Indianapolis (hereafter JHAI), April 13-May 5
1914	Exhibits metalwork and jewelry at *Seventh Annual Exhibition of Works by Indiana Artists*, JHAI, March 6-April 5
	Spends summer in Long Beach, New York, and works in Manhattan at the Gorham Studios and at the Morgan Library
	Exhibits metalwork and jewelry at *Thirteenth Annual Exhibition of Examples of Industrial Art and Original Designs for Decorations*, Art Institute of Chicago, October 1-25
1915	Exhibits metalwork and jewelry at *Panama-Pacific International Exposition*, San Francisco, and wins bronze medal (third prize)
	Wins *prix d'honneur* from Metal Guild (part of National Society of Craftsmen)
1916	Publishes *The Complete Story of the Christmas Tree* for Dunstan, New York
1917	Publishes *Gossamer to Steel* for Dunstan, New York
1919	Exhibits metalwork and jewelry at *Twelfth Annual Exhibition of Works by Indiana Artists*, JHAI, March 9-April 20
	Exhibits metalwork and jewelry at *An Exhibit of Decorative Art*, JHAI, November 9-30
1920	Exhibits metalwork and jewelry at *Thirteenth Annual Exhibition of Works by Indiana Artists*, JHAI, March 7-April 4
1920-25	Lectures at various midwest locations on her work and philosophy
1921	Exhibits metalwork and jewelry at *Fourteenth Annual Exhibition of Works by Indiana Artists*, JHAI, March 6-April 3
	Exhibits metalwork and jewelry at *Nineteenth Annual Exhibition of Applied Arts*, Art Institute of Chicago, March 8-April 5
	Exhibits metalwork and jewelry at *68th Annual Indiana State Fair*, Indianapolis, September 5-10
1922	Exhibits metalwork and jewelry at *Fifteenth Annual Exhibition of Works by Indiana Artists*, JHAI, March 5-April 22
	Exhibits metalwork and jewelry at Teachers Convention, Manual Training High School, Indianapolis, October 20
	Exhibits metalwork and jewelry at *69th Annual Indiana State Fair*, Indianapolis, September 4-9
1923	Exhibits metalwork and jewelry at *Sixteenth Annual Exhibition by Indiana Artists and Craftsmen*, JHAI, March 4-April 1

1924	Exhibits metalwork and jewelry at *Seventeenth Annual Exhibition by Indiana Artists and Craftsmen*, JHAI, March 2-30
	Exhibits metalwork and jewelry at Shortridge High School, Indianapolis, May
	Exhibits metalwork and jewelry at *71st Annual Indiana State Fair*, Indianapolis, September 1-5
	Exhibits with other artists at Art Center, New York, December 1-31
1925	Travels to Paris: visits *Exposition Internationale des Arts Décoratifs et Industriels Modernes* and takes one-month philosophy course at the Sorbonne
	Exhibits metalwork and jewelry at *Eighteenth Annual Exhibition of Work by Indiana Artists and Craftsmen*, JHAI, March 1- 29
	Exhibits metalwork and jewelry at *72nd Annual Indiana State Fair*, Indianapolis, September 7-14
	Exhibits metalwork and jewelry at *Mid-West Circuit Exhibition of Modern American Handicraft*, JHAI, December 6-27
	Visits Geneva and studies with metal crafters at the University of Geneva
1926	Visits Italy and attends lectures in Florence on the Italian Renaissance given by Bernard Berenson
	Exhibits metalwork and jewelry at *Nineteenth Annual Exhibition of Work by Indiana Artists and Craftsmen*, JHAI, March 7- 28 (first prize; Art Association Applied Arts Prize)
	Exhibits metalwork and jewelry at *73rd Annual Indiana State Fair*, Indianapolis, September 4-11
1927	Visits Paris and Moscow
	Exhibits metalwork and jewelry at *Twentieth Annual Exhibition of Work by Indiana Artists and Craftsmen*, JHAI, March 6- 27
	Exhibits metalwork and jewelry at *74th Annual Indiana State Fair*, Indianapolis, September 3-10
1928	Travels to Russia with group of educators led by John Dewey to study Soviet educational system
	Exhibits metalwork and jewelry at *Twenty-first Annual Exhibition of the Work of Indiana Artists and Craftsmen*, JHAI, February 29-March 27
1929	Begins teaching pottery courses at Shortridge High School
	Exhibits metalwork and jewelry at *Twenty-second Annual Exhibition of the Work of Indiana Artists and Craftsmen*, JHAI, March 3-31
	Exhibits metalwork and jewelry at *Twenty-third Annual Exhibition of the Work of Indiana Artists and Craftsmen*, JHAI, November 3-December 1
1929-30	Solo exhibition at Art Center, New York City, December-January
1931	Exhibits metalwork and jewelry at *Twenty-fourth Annual Exhibition of the Work of Indiana Artists*, JHAI, March 1-29
1933	Exhibits metalwork and jewelry at *Twenty-sixth Annual Exhibition of the Work of Indiana Artists*, JHAI, March 5-April 2
1934	Exhibits metalwork and jewelry at Shortridge High School, January
	Exhibits metalwork and jewelry at *Twenty-seventh Annual Exhibition of the Work of Indiana Artists*, JHAI, March 4-April 1

1935	Exhibits metalwork and jewelry at *Twenty-eighth Annual Exhibition of Work by Indiana Artists*, JHAI, March 3-31
	Solo exhibition at John Herron Art Institute, Indianapolis, April 18-May 2
1939	Presents lecture, "The Step-Off," at Portfolio Club, Indianapolis
1942	Retires from teaching
1948	Dies Sunday, July 18, following short illness
1968	120 pieces of her metalwork donated to John Herron Art Institute, Indianapolis (now Indianapolis Museum of Art), by Mira and Jan Bowles in memory of their mother
1968-69	120-piece collection of metalwork and jewelry exhibited at John Herron Art Institute, Indianapolis, November 29-January 16
1981	Five additional pieces by Payne Bowles, plus her bronze medal from the *Panama-Pacific International Exposition*, donated to the Indianapolis Museum of Art by Mira Bowles
1991-92	Eight pieces of Payne Bowles's metalwork and jewelry exhibited at *Independent Spirit: Art by Indiana Women 1890-1950*, presented at the Indianapolis Museum of Art, June 1991-January 1992
1993-94	Exhibition *The Arts & Crafts Metalwork of Janet Payne Bowles* presented at the Munson-Williams-Proctor Institute Museum of Art, September 4, 1993-January 3, 1994, and at the Indianapolis Museum of Art, April 9-May 22, 1994

PLATE 70

Pitcher
ca. 1929
cat. 125

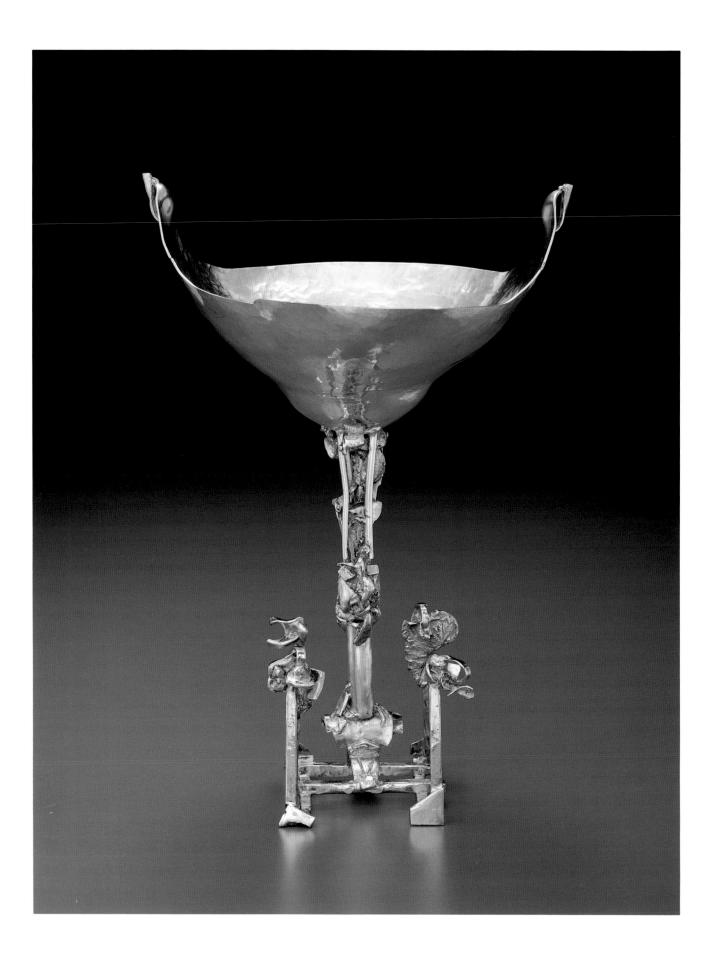

Catalogue of the Janet Payne Bowles Collection

This list of objects is arranged in chronological sequence. All measurements are height times width times depth; single measurements are height or length or, in the case of rings, the length of the design. All measurements are in inches followed by centimeters. Objects in the traveling exhibition and illustrated in this catalogue bear a plate number. Unless otherwise noted, all objects are the gift of Jan and Mira Bowles in memory of their mother, Janet Payne Bowles. Full citations of abbreviated publications can be found in the bibliography.

1

The Second Epistle of John
1901
Limited edition of 15
Illuminated by Janet Payne Bowles; printed and retailed by Joseph Moore Bowles.
Bound paper, aqueous paints
4¾ x 3¾ (12.0 x 9.5)
Lent by Theodore L. Steele

Plate 2

2

Pendant with chain
ca. 1907-11
Silver, plastic
Pendant: 2¾ (7.0); chain: 20 (50.8)
68.21.32

Plate 11

3

Cross pendant with chain
ca. 1907-11
Silver, tourmaline
Pendant: 3¼ x 2¼ (8.2 x 5.7);
chain: 9½ (24.1)
68.21.53

Exhibited: John Herron Art Institute, *Nineteenth Annual Exhibition...*, 1926, first prize; Art Center, New York, Dec. 1929.

Published: *Indiana Daily Times*, Sept. 22, 1917; Sharkey, A. M., "Art Center Notes," *Bulletin of the Art Center, New York*, Jan. 1925, p. 123; Buschmann; Shapiro.

Plate 4

4

Pendant with chain
ca. 1907-11
Silver with gold wash, gold, amethyst, and green glass
Pendant: 1¾ (4.5); chain: 7 (17.8)
68.21.31

Plate 12

5

Pendant
ca. 1907-11
Cast silver, lapis lazuli, enamel
2½ (6.3)
68.21.52

Exhibited: Art Center, New York, Dec. 1929.

Published: *Indianapolis Star*, Dec. 21, 1930.

Plate 13

6

Belt clasp/ pendant
ca. 1907-11
Copper with gold wash
Clasp: 1¾ (4.5); chain: 7 (17.8)
68.21.92

Exhibited: John Herron Art Institute, *Nineteenth Annual Exhibition...*, 1926, first prize.

Published: Buschmann; Kohlman 1924, p. 56.

Plate 14

Plate 71. *Chalice*, ca. 1925-31 (cat. 122)

7

Ring
ca. 1907-11
Opal rose gold with yellow gold wash;
blue/green glass stones
1½ (3.8)
68.21.88

Exhibited: John Herron Art Institute,
Nineteenth Annual Exhibition..., 1926, first
prize; Art Center, New York, Dec. 1929.

Plate 16

8

Pendant
ca. 1907-11
Pearl, silver and copper wire
3¼ (8.2)
68.21.94

Exhibited: John Herron Art Institute,
Nineteenth Annual Exhibition..., 1926,
first prize.

Plate 15

9

Pendant with chain
ca. 1910-12
Cast bronze, copper wire, gold wash, silver,
rose gold with yellow gold wash,
cotton cord
Pendant: 2¾ (7.0)
68.21.56

Plate 17

10

Pendant with chain
ca. 1910-12
Silver, moonstone (orthoclase feldspar)
Pendant: 1½ (3.8); chain: 7½ (19.0)
68.21.68

Plate 18

11

Ring
ca. 1910-12
Silver
1 (2.5)
68.21.63

Plate 20

12

Ring
ca. 1910-12
Silver
1½ (3.8)
68.21.66

Plate 21

13

Pendant with chain
ca. 1910-12
Copper with gold wash, gold, gold
tourmaline
Pendant: 2¼ (5.7); chain: 7 (17.8)
68.21.93

Plate 19

14

Pendant with chain
ca. 1910-12
Bronze, silver wire, yellow gold, round glass
disk (orange/white), plastic black stone,
cotton cord
Pendant: 3½ (8.9)
68.21.55

Published: Buschmann.

Plate 5

15

Hand towel
ca. 1912-15
Linen
14½ x 25½ (36.8 x 64.7)
81.868

16

Spoon
ca. 1912-15
Silver
7 (17.8)
68.21.25

Exhibited: Indianapolis Museum of Art,
*Independent Spirit: Art by Indiana Women
1890-1950*, June 1991-Jan. 1992.

Plate 23

17

Spoon
ca. 1912-15
Silver
4⅛ (10.5)
68.21.26

18

Ring
ca. 1912-15
Silver, gold
¾ (1.9)
68.21.34

19

Ring
ca. 1912-15
Silver, gold
2 (5.0)
68.21.62

Plate 22

20

Ring
ca. 1912-15
Gold
1⅜ (3.5)
68.21.71

21

Ring
ca. 1912-15
Gold
1¼ (3.2)
68.21.72

22

Ring
ca. 1912-15
Silver
1½ (3.8)
68.21.75

Exhibited: John Herron Art Institute,
Seventeenth Annual Exhibition..., 1924.

23

Ring
ca. 1912-15
Silver, pearl
1⅝ (4.1)
68.21.77

24

Ring
ca. 1912-15
Silver, gold, brass
1 (2.5)
68.21.78

25

Ring
ca. 1912-15
Silver, gold
1½ (3.8)
68.21.80

26

Ring
ca. 1912-15
Silver
1½ (3.8)
68.21.82

27

Ring
ca. 1912-15
Silver, gold, tiger eye
1⅝ (4.1)
68.21.90

28

Spoon
ca. 1912-15
Silver, mother-of-pearl
6½ (16.5)
68.21.99

Plate 24

29

Spoon
ca. 1912-15
Silver
3½ (8.9)
68.21.100

30

Cheese scoop
ca. 1912-15
Silver
8⅛ (20.6)
68.21.118

31

Spoon
ca. 1912-15
Silver
4¾ (12.0)
68.21.20

Published: Kohlman 1924, p. 57.

32

Spoon
ca. 1912-15
Silver
Marks: struck incuse: JANET / PAYNE / BOWLES
5 (12.7)
68.21.21

Published: Kohlman 1924, p. 57.

Plate 25

33

Spoon
ca. 1912-15
Silver
3½ (8.9)
68.21.105

Published: Kohlman 1924, p. 57.

Plate 26

34

Spoon
ca. 1912-15
Silver
2½ (6.3)
68.21.110

Exhibited: John Herron Art Institute,
Seventeenth Annual Exhibition..., 1924.

Published: Kohlman 1924, p. 57; McNault.

Plate 27

35

Spoon
ca. 1912-15
Silver
3½ (8.9)
68.21.111

Exhibited: John Herron Art Institute,
Seventeenth Annual Exhibition..., 1924.

Published: Kohlman 1924, p. 57; McNault.

Plate 28

36

Spoon
ca. 1912-15
Silver
5 (12.7)
68.21.114

Exhibited: John Herron Art Institute,
Seventeenth Annual Exhibition..., 1924.

Published: Kohlman 1924, p. 57; McNault.

Plate 29

37

Brooch
ca. 1912-15
Copper, brass, silver
1½ (3.8)
68.21.48

Plate 30

38

Stick pin/pendant
ca. 1912-15
Silver, green stone (malachite and gold wash)
2¾ (7.0)
68.21.49

Plate 31

39

Ring
ca. 1912-15
Silver, gold, copper, green glass
1⅜ (3.5)
68.21.60

Exhibited: John Herron Art Institute, *Seventeenth Annual Exhibition...*, 1924.

40

Pendant
ca. 1912-15
Silver, gold, copper
2¼ (5.7)
68.21.73

Exhibited: Art Center, New York, Dec. 1929.

Plate 32

41

Ring
ca. 1912-15
Silver, gold, green stone
1 (2.5)
68.21.86

Exhibited: John Herron Art Institute, *Seventeenth Annual Exhibition...*, 1924.

42

Pendant
ca. 1912-15
Gold wash, baroque pearl, copper
3 (7.6)
68.21.95

Exhibited: John Herron Art Institute, *Seventeenth Annual Exhibition...*, 1924.

Plate 33

43

Spoon
ca. 1912-15
Silver
Marks: monogrammed JPB (in well)
5 (12.7)
68.21.103

Exhibited: John Herron Art Institute, *Seventeenth Annual Exhibition...*, 1924.

Published: McNault.

Plate 34

44

Spoon
ca. 1912-15
Silver
3½ (8.9)
68.21.104

Published: Kohlman 1924, p. 57.

Plate 35

45

Spoon
ca. 1912-15
Silver
5½ (14.0)
68.21.113

Exhibited: Indianapolis Museum of Art, *Independent Spirit....*

Published: Kohlman 1924, p. 57.

Plate 36

46

Ring
ca. 1912-15
Gold, moonstone (orthoclase feldspar)
1½ (3.8)
68.21.69

Exhibited: John Herron Art Institute, *Nineteenth Annual Exhibition...*, 1926, first prize.

47

Pendant
ca. 1912-15
Silver
3 (7.6)
68.21.81

Exhibited: John Herron Art Institute, *Nineteenth Annual Exhibition...*, 1926, first prize.

Plate 37

48

Pectoral cross
ca. 1912-15
Cast silver, lapis lazuli
Pendant: 3¼ x 2¼ (8.3 x 5.7)
68.21.54

Exhibited: Art Center, New York,
Dec. 1929.

Publlished: Buschmann; Shapiro; *Indianapolis Star*, Dec. 21, 1930.

Plate 38

49

Ring
ca. 1912-15
Gold, citrine
1⅜ (3.5)
68.21.70

Exhibited: Art Center, New York,
Dec. 1929.

50

Box
ca. 1913
Lead, glass
Marks: JANET PAYNE BOWLES (on reverse)
2 x 3 x 2½ (5.0 x 7.6 x 6.3)
68.21.9

Published: Kohlman 1924, p. 54; *Indiana Daily Times*, 1917.

Plate 39

51

Box
ca. 1913
Copper, silver, yellow glass stone
2½ x 3⅛ x 2 (6.3 x 8.0 x 5.0)
68.21.10

Exhibited: Indianapolis Museum of Art,
Independent Spirit....

Plate 40

52

Spoon
ca. 1915-20
Silver
5¾ (14.6)
68.21.24

Published: Kohlman 1924, p. 57.

53

Spoon
ca. 1915-20
Silver
5 (12.7)
68.21.101

Published: Kohlman 1924, p. 57.

Plate 41

54

Spoon
ca. 1915-20
Silver
6 (15.2)
68.21.106

Exhibited: John Herron Art Institute,
Seventeenth Annual Exhibition..., 1924.

Published: Kohlman 1924, p. 57; McNault.

Plate 42

55

Ladle
ca. 1916-19
Silver, and gold wash
11½ (29.2)
68.21.11

Plate 43

56

Chalice
ca. 1916-20
Silver
Marks: JANET / PAYNE / BOWLES
(within a circle)
4 (10.1)
68.21.4

Plate 44

57

Spoon
ca. 1916-20
Silver
6 (15.2)
68.21.18

Plate 45

58

Spoon
ca. 1916-20
Silver
3½ (8.9)
68.21.14

Plate 46

59

Spoon
ca. 1916-20
Silver
5¼ (13.3)
68.21.15

60

Spoon
ca. 1916-20
Silver
7⅜ (18.7)
68.21.17

61

Spoon
ca. 1916-20
Silver
3½ (8.9)
68.21.22

62

Spoon
ca. 1916-20
Silver
5¾ (14.6)
68.21.23

63

Ring
ca. 1916-20
Silver
1½ (3.8)
68.21.45

64

Ring
ca. 1916-20
Silver, gold, wire, orange plastic stone with gold and black oil enamel paint
1½ (3.8)
68.21.59

Plate 49

65

Fork
ca. 1916-20
Silver, copper
7 (17.8)
68.21.27

66

Ring
ca. 1916-20
Silver
1⅛ (2.8)
68.21.35

Plate 8

67

Ring
ca. 1916-20
Silver, white molded plastic stone
1⅝ (4.1)
68.21.85

68

Spoon
ca. 1916-20
Copper with gold wash
7 (17.8)
68.21.102

Exhibited: Indianapolis Museum of Art,
Independent Spirit. . . .

Plate 47

69

Spoon
ca. 1916-20
Silver
4½ (11.4)
68.21.19

Plate 48

70

Hair Pin
ca. 1916-20
Copper
2½ (6.3)
68.21.28

71

Hair pin
ca. 1916-20
Brass
3¼ (8.2)
68.21.29

Plate 9

72

Ring
ca. 1916-20
Silver
⅞ (2.2)
68.21.64

Exhibited: John Herron Art Institute,
Seventeenth Annual Exhibition . . ., 1924.

73

Ring
ca. 1916-20
Silver, blue glass
1¼ (3.2)
68.21.84

Exhibited: John Herron Art Institute,
Seventeenth Annual Exhibition . . ., 1924.

74

Ring
ca. 1916-20
Gold
¾ (1.9)
68.21.87

Exhibited: John Herron Art Institute,
Seventeenth Annual Exhibition . . ., 1924.

75

Spoon
ca. 1916-20
Silver
4½ (11.4)
68.21.108

Exhibited: John Herron Art Institute,
Seventeenth Annual Exhibition . . ., 1924.

Published: McNault.

76

Ring
ca. 1916-20
Silver, gold
1⅜ (3.5)
68.21.57

Exhibited: John Herron Art Institute,
Nineteenth Annual Exhibition . . ., 1926,
first prize.

77

Button hook
ca. 1916-20, by 1931
Silver, mother-of-pearl (possibly silver plate)
3¾ (9.5)
68.21.50

78

Ring
ca. 1916-24
Silver, gold
1⅛ (2.8)
68.21.79

79

Ring
ca. 1916-31
Gold
1 (2.5)
81.786

Made for Janet's daughter, Mira.

Plate 50

80

Ring
ca. 1916-31
Silver
¾ (1.9)
81.866

Made for Janet's daughter, Mira.

Plate 51

81

Coffeepot
ca. 1921 (ewer itself is probably Russian or American, 1905-21)
Copper, silver
15 (38.1)
Julius F. Pratt Fund
1992.70

Published: Kohlman 1924, p. 55 (in altered form)

Plate 6

82

Chalice
ca. 1921-23
Silver, gold wash on copper inside bowl
9 (22.9)
68.21.5

Exhibited: John Herron Art Institute, *Nineteenth Annual Exhibition*..., 1926; Art Center, New York, Dec. 1929.

Published: Kohlman 1924, p. 55; *Bulletin of the Art Center, New York* 8, no. 3 (Dec. 1929).

Plate 52

83

Ring
ca. 1921-23
Gold, pink glass stone
1¼ (3.2)
68.21.46

84

Ring
ca. 1921-23
Gold, pink glass stone
½ (1.2)
68.21.47

Exhibited: Art Center, New York, Dec. 1929.

85

Ladle
ca. 1921-24
Silver, gold wash on copper
5 (12.7)
68.21.16

Plate 53

86

Spoon
ca. 1921-24
Silver
5¼ (13.3)
68.21.12

87

Spoon
ca. 1921-24
Silver
5 (12.7)
68.21.13

Plate 54

88

Ring
ca. 1921-24
Silver
2 (5.0)
68.21.43

Plate 55

89

Ring
ca. 1921-24
Silver
1¾ (4.5)
68.21.58

90

Ring
ca. 1921-24
Silver
1½ (3.8)
68.21.65

91

Spoon
ca. 1921-24
Silver
7⅛ (18.1)
68.21.96

Plate 59

92

Spoon
ca. 1921-24
Silver with touches of gold wash
7 (17.8)
68.21.97

93

Spatula
ca. 1921-24
Silver
9½ (24.1)
68.21.119

Plate 60

94

Tea infuser with chain
ca. 1921-24
Silver
5¾ (14.6)
68.21.117

95

Ring
ca. 1921-24
Silver with spot of copper
1½ (3.8)
68.21.67

Exhibited: John Herron Art Institute, *Seventeenth Annual Exhibition*..., 1924.

Plate 56

96

Ring
ca. 1921-24
Gold, rose gold with yellow gold wash, green chalcedony (jasper)
1¼ (3.2)
68.21.91

Exhibited: John Herron Art Institute, *Seventeenth Annual Exhibition*..., 1924.

Plate 57

97

Butter knife
ca. 1921-24
Silver
7 (17.8)
68.21.107

Exhibited: John Herron Art Institute,
Seventeenth Annual Exhibition..., 1924.

Published: McNault.

Plate 61

98

Fork
ca. 1921-24
Silver
7½ (19.0)
68.21.115

Exhibited: John Herron Art Institute,
Seventeenth Annual Exhibition..., 1924;
Indianapolis Museum of Art, *Independent
Spirit....*

Published: Buschmann; McNault.

Plate 62

99

Paper knife
ca. 1921-24
Silver
4½ (11.4)
68.21.30

Exhibited: John Herron Art Institute,
Nineteenth Annual Exhibition..., 1926, first
prize.

Plate 7

100

Ring
ca. 1921-24
Silver, mother-of-pearl
1 (2.5)
68.21.38

Exhibited: Art Center, New York, Dec. 1929.

Plate 58

101

Server
ca. 1921-24
Silver
8 (20.3)
68.21.116

Published: Buschmann; *Indianapolis News*,
Mar. 7, 1925.

Plate 10

102

Ring
ca. 1925-26
Silver
1½ (3.8)
68.21.74

Exhibited: John Herron Art Institute,
Nineteenth Annual Exhibition..., 1926, first
prize.

Plate 63

103

Chalice
ca. 1925-28
Silver, gold
9¾ (24.7)
68.21.2

Exhibited: Art Center, New York, Dec.
1929; *"The Art That is Life": The Arts &
Crafts Movement in America, 1875-1920*,
Museum of Fine Arts, Boston, 1987.

Published: *Indianapolis Star*, Dec. 21, 1930.

Plate 1

104

Ring
ca. 1925-29
Silver, gold
1⅜ (3.5)
68.21.37

105

Font
ca. 1925-29
Silver
7⅜ (18.7)
68.21.7

Exhibited: Art Center, New York, Dec.
1929.

Published: Buschmann; Stewart; *Indianapolis
Star*, Dec. 21, 1930.

Frontispiece

106

Fork
ca. 1925-29
Silver
9⅝ (24.5)
68.21.98

Exhibited: Art Center, New York, Dec.
1929.

Published: *Indianapolis Star*, Dec. 21, 1930.

Plate 3

107

Chalice or salt stand
ca. 1925-30
Silver
8 (20.3)
68.21.6

Exhibited: Art Center, New York, Dec. 1929; Indianapolis Museum of Art, *Independent Spirit....*

Published: *Indianapolis Star*, Dec. 21, 1930.

Plate 67

108

Ring
ca. 1925-31
Silver, gold, and red glass
1⅝ (4.1)
68.21.33

109

Ring
ca. 1925-31
Silver
1⅝ (4.1)
68.21.36

110

Ring
ca. 1925-31
Silver
⅝ (1.6)
68.21.39

111

Ring
ca. 1925-31
Silver
1¾ (4.5)
68.21.40

112

Ring
ca. 1925-31
Silver
1½ (3.8)
68.21.41

113

Ring
ca. 1925-31
Probably cupror
¾ (1.9)
68.21.42

114

Ring
ca. 1925-31
Silver
1½ (3.8)
68.21.44

115

Pendant
ca. 1925-31
Silver
2¾ (7.0)
68.21.51

Plate 64

116

Ring
ca. 1925-31
Silver
1½ (3.8)
68.21.61

117

Ring
ca. 1925-31
Silver
1¾ (4.5)
68.21.83

118

Ring
ca. 1925-31
Gold, rose gold with yellow gold wash, silver, micro-mosaic
1 (2.5)
68.21.89

119

Spoon
ca. 1925-31
Silver
3¾ (9.5)
68.21.109

120

Spoon
ca. 1925-31
Silver
4 (10.1)
68.21.112

Plate 65

121

Fork
ca. 1925-31
Silver
8⅞ (22.5)
68.21.120

Plate 66

122

Chalice
ca. 1925-31
Silver
9 (22.9)
68.21.1

Cover; Plate 71

123

Chalice
ca. 1925-31
Silver
9 (22.9)
68.21.3

Exhibited: Indianapolis Museum of Art, *Independent Spirit....*

Plate 68

124

Reliquary
ca. 1926-27
Silver
6¾ x 5½ x 4 (17.1 x 14.0 x 10.1)
68.21.8

Exhibited: Art Center, New York, Dec. 1929.

Published: Buschmann; Stewart; *Indianapolis Star*, Dec. 21, 1930; July 19, 1948.

Plate 69

125

Pitcher
ca. 1929
Earthenware
5⅜ x 2½ x 9 (13.6 x 6.3 x 22.9)
81.865

Plate 70

Selected Bibliography

Allen, Jay Wilson. *William James.* New York, 1967.

American Art Annual 27 (Washington, D.C., 1930), p. 511.

"American Educators in Russia," *School and Society* 27, no. 705 (June 30, 1928), p. 779.

Bain, George. *Celtic Art, The Methods of Construction.* New York, (1951) 1973.

Baltimore, Walters Art Gallery. *Jewelry Ancient to Modern*, exh. cat., New York, 1980.

Baltimore and New York, Walters Art Gallery and American Federation of Arts. *Objects of Adornment: Five Thousand Years of Jewelry from the Walters Art Gallery, Baltimore*, exh. cat., New York, 1984.

Boris, Eileen. *Art and Labor: Ruskin, Morris, and the Craftsman Ideal in America.* Philadelphia, 1986.

Boruff, Blanche Foster, comp. *Women of Indiana*, Indiana Women's Biography Association, Matthew Farson, Indianapolis, 1941.

Boston, Copley Hall. *Catalogue of the Exhibition of the Society of Arts and Crafts*, exh. cat. April 4-15, 1899. Boston, 1899.

——————. *Catalogue of the First Exhibition of Arts and Crafts*, exh. cat. April 5-15, 1897. Boston, 1897.

Bowles, Janet Payne. "Artistic Dress for Children," *The Craftsman* 6, no. 1 (Apr. 1904), pp. 62-65.

——————. *The Complete Story of the Christmas Tree.* New York, 1916.

——————. *Gossamer to Steel.* New York, 1917.

——————. "A Situation in Craft Jewelry," *Handicraft* 3, no. 9 (Dec. 1910), pp. 309-20; reprint in *The Jewelers' Circular Weekly* 62 (Feb. 1, 1911), pp. 109, 111.

——————. "The Step-Off," unpublished manuscript, 1939. Collection of Jerome Sikorski.

Bowles, Joseph Moore. "William Morris as a Printer: The Kelmscott Press," *Modern Art* 2, no. 4 (Autumn 1894), n.p.

——————. "An American 'Arts and Crafts,' " *Modern Art* 5, no. 1 (Winter 1897), pp. 17-20.

——————. "To Zigzag or Not to Zigzag?, For the Negative: Frederick Lewis, For the Affirmative: J.M. Bowles," *Advertising & Selling* 11 (July 11, 1928), pp. 21-22, 53, 56.

_____. "The Early Work of Bruce Rogers," in *BR Mark & Remark: the Marks by Bruce Rogers et al*, The Typophiles in New York, 1946, pp. 15-30.

Bowles, Mira. *We Tell Our Story*. Indianapolis, 1957.

Brandt, Beverly Kay. "Mutually Helpful Relations: Architects, Craftsmen and The Society of Arts and Crafts, Boston, 1897-1917," Ph.D. diss., Boston University, 1985.

Brenton, Guy. "Indianapolis Women Win in Many Lines of Business and Professions," *The Indianapolis Star*, Sept. 6, 1922.

Buffalo, Society of Artists. *Joint Annual Exhibition of Buffalo Society of Artists, Art Students League, American Institute of Architects, Including An Exhibition of Arts and Crafts*, exh. cat. Buffalo, 1900.

Burnet, Mary Q. *Art and Artists of Indiana*. New York, 1921.

Buschmann, Florenz K. "Janet Payne Bowles Knows Art of Changing Metals Into Beauty," *The Indianapolis Star*, Apr. 20, 1930.

Callen, Anthea. *Women Artists of the Arts and Crafts Movement, 1870-1914*. New York, 1979.

Campbell, Harry M. *John Dewey*. New York, 1971.

Carper, Sister M. Dolorita, O.S.F. *A History of the John Herron Art Institute*, M.A. thesis, College of Education, Butler University, Indianapolis, 1947.

Chicago, Art Institute of Chicago. *Bulletin of the Art Institute of Chicago* 8, no. 2 (Oct. 1914), p. 17; 15, no. 2 (Feb. 1921), p. 127.

_____. *Catalogue of the Nineteenth Annual Exhibition of Applied Arts*, exh. cat. Chicago, 1921.

_____. *Catalogue of the Thirteenth Annual Exhibition of Examples of Industrial Art and Original Designs for Decorations*, exh. cat. Chicago, 1914.

_____. *Catalogue of the Twenty-Third Annual Exhibition of Modern Decorative Art at The Art Institute of Chicago*, exh. cat. Chicago, 1924.

Chicago, Arts and Crafts Society. *First Exhibition of the Chicago Arts and Crafts Society*, exh. cat. Chicago, 1899.

Clark, Robert Judson, ed. *Aspects of the Arts and Crafts Movement in America, Record of the Princeton Art Museum* 34, no. 2 (1975).

Cotkin, George. *Reluctant Modernism; American Thought and Culture, 1880-1900*. New York, 1992.

Darling, Sharon S. *Chicago Metalsmiths*. Chicago, 1977.

Dewey, John. *Democracy and Education*. New York, (1916) 1966.

_____. *Experience and Education*. New York, (1938) 1956.

_____. *Impressions of Soviet Russia and The Revolutionary World, Mexico-China-Turkey*. New York, 1929.

_____. *The School and Society*. Chicago, (1943) 1956.

Dow, Arthur Wesley. *Composition*, 7th rev. ed. Garden City, N.J., 1913.

Dykhuizen, George. *The Life and Mind of John Dewey*, Carbondale and Edwardsville, Ill., 1973.

Edelstein, T. J. *Imagining an Irish Past: The Celtic Revival 1840-1940*, exh. cat., The David and Alfred Smart Museum of Art, The University of Chicago. Chicago, 1992.

Finlay, Nancy. *Artists of the Book in Boston, 1890-1910*, Department of Printing and Graphic Arts, The Houghton Library, Harvard College Library. Cambridge, Mass., 1985.

Fosdick, J. W[illiam]. "American Handicraft," *Art and Progress* 1 (Feb. 1911), p. 102.

_____. "The Fourth Annual Exhibition of the National Society of Craftsmen," *International Studio* 42 (Feb. 1911), p. LXXXI.

"Fourth Annual Exhibition of Arts and Crafts Opens at the National Arts Club," *The Jewelers' Circular Weekly* 61 (Dec. 21, 1910), p. 63.

Gaus, Laura Sheerin. *Shortridge High School, 1864-1981*. Indianapolis, 1985.

Gombrich, E. H. *The Sense of Order: A Study in the Psychology of Decorative Art*. Ithaca, N.Y., 1979.

Harris, Leon. *Upton Sinclair. American Rebel*. New York, 1975.

Hayden, Dolores. *The Grand Domestic Revolution*. Cambridge, Mass., 1981.

Hayward, J. F. *Virtuoso Goldsmiths and the Triumph of Mannerism 1549-1620*. New York and London, 1976.

Heller, Adele, and Lois Rudnick, eds. *1915, The Cultural Movement*. New Brunswick, N.J., 1991.

Hendricks, Bessie, in *Indianapolis News*: "Photographs, Etchings and Applied Arts Hold Interest," Nov. 22, 1919; "Notes About Art and Artists," July 23, 1921; "In the Indiana Exhibition at the Art Institute," Mar. 18, 1922.

Hutchings, Grace. "Applied Arts Display Gains New Features," *Indiana Daily Times*, Nov. 22, 1919.

Indiana Daily Times: "'Craft-Woman' Plies Art in Indianapolis," Sept. 22, 1917; "Indianapolis Woman Said to Rank Highly Among Gem Workers," Nov. 29, 1920.

Indianapolis, Indianapolis High School. *First Exhibition of the Arts and Crafts*, exh. cat., April 15-23, 1898.

Indianapolis, John Herron Art Institute. *Bulletin of the Art Association of Indianapolis, Indiana* 6, no. 2 (Feb. 1918), p. 6; 12, no. 3 (Mar. 1925), pp. 19-27; 14, no. 2 (Mar. 1927), pp. 11-12.

_____. *Catalogue of An Exhibition of Decorative Arts*. Indianapolis, 1919.

_____. *Catalogue of The Mid-West Circuit Exhibition of Modern American Handicraft*. Indianapolis, 1925.

_____. *Catalogue of the Fifth Annual Exhibition of Works by Indiana Artists*, 1912; *Catalogue of the Seventh Annual Exhibition . . .*, 1914; *Catalogue of the Twelfth Annual Exhibition . . .*, 1919; *Catalogue of the Thirteenth Annual Exhibition . . .*, 1920; *Catalogue of the Fourteenth Annual Exhibition . . .*, 1921; *Catalogue of the Fifteenth Annual Exhibition . . .*, 1922; *Catalogue of the Sixteenth Annual Exhibition . . .*, 1923; *Catalogue of the Seventeenth Annual Exhibition . . .*, 1924; *Catalogue of the Eighteenth Annual Exhibition . . .*, 1925; *Catalogue of the Nineteenth Annual Exhibition . . .*, 1926; *Catalogue of the Twentieth Annual Exhibition . . .*, 1927; *Catalogue of the Twenty-First Annual Exhibition . . .*, 1928; *Catalogue of the Twenty-Second Annual Exhibition . . .*, 1929; *Catalogue of the Twenty-Third Annual Exhibition . . .*, 1929; *Catalogue of the Twenty-Fourth Annual Exhibition . . .*, 1931; *Catalogue of the Twenty-Sixth Annual Exhibition . . .*, 1933; *Catalogue of the Twenty-Seventh Annual Exhibition. . .*, 1934; *Catalogue of the Twenty-Eighth Annual Exhibition . . .*, 1935.

Indianapolis News: "Fine Arts and Crafts," Apr. 14, 1898; "Art Exhibition Opened," Apr. 15, 1898; "At Arts and Crafts Show," Apr. 19, 1899; "Work of High Quality in Keramic

Exhibit," Nov. 24, 1903; "J. M. Bowles Family in Upton Sinclair Fire," Mar. 18, 1907; "German Art Original Not Always Beautiful," Oct. 2, 1912; "German Applied Arts Have Interested Many," Oct. 25, 1912; "Art Notes," May 10, 1913; "Arts and Crafts Work at the Art Institute," Apr. 18, 1914; "Indiana Women Prepare for Frisco Exhibition," Dec. 18, 1914; "Morris Exhibit and Talk," Jan. 12, 1915; "Indianapolis School Notes," Jan. 12, 1915; "Miss Dye on William Morris," Jan. 14, 1915; "Pottery Exhibit One of Special Art Displays," Feb. 20, 1915; "Get Awards at Exposition," Aug. 3, 1915; "Novel by Shortridge Teacher," May 25, 1917; "Art Notes," Oct. 27, 1917; "Applied Arts Display Opens Sunday at Art Institute," Nov. 8, 1919; "Art Notes," Feb. 12, 1921; "Hoosier Group Paintings and Other Art Exhibits," June 11, 1921; "Charity Dye, Widely Known Teacher, Dead," July 19, 1921; "Applied Art Examples an Important Phase of This Year's Indiana Artists' Exhibition," Mar. 24, 1923; "Tributes Paid Dead Shortridge Teacher," Nov. 17, 1924; "Among the Exhibits of Indiana Artists and Craftsmen at the John Herron Art Institute," Mar. 7, 1925; "Mrs. Janet Bowles Rites Here Tuesday," July 19, 1948, part 2.

Indianapolis Star: "Art Institute to Open Oct. 1," Sept. 22, 1912; "Art Institute Will be Scene of Unusual Exhibit," Sept. 29, 1912; "Art Institute Open to Public," Oct. 2, 1912; "Metal Artist Gaining Fame," Apr. 27, 1914; "Many Exhibits for Women," Sept. 4, 1920, State Fair section; "Wins High Award Second Time for Jewelry Designs," Jan. 28, 1921; "Dye Rites to be Held Tomorrow," July 20, 1921; "Charity Dye Was Leader in Many Civic Activities," July 31, 1921; "State Fair Awards," Sept. 9, 1921; "State Fair Awards," Sept. 5, 1922; "State Fair Awards," Sept. 2, 1924; "Indiana State Fair Awards," Sept. 9, 1925; "Indiana State Fair Awards," Sept. 7, 1926; "Work of Mrs. Bowles, Indianapolis Goldsmith, Exhibited in New York," Jan. 5, 1930; "Teachers Jewelry Craft Work," Dec. 21, 1930, alco-gravure section; "Mrs. Bowles, Famed Jewelry Designer, Dies," July 19, 1948; "Lieber's 100 Years of Serving You!," Apr. 25, 1954.

Jackson, Stanley. *J. P. Morgan*. New York, 1983.

Jessup, Ronald. *Anglo-Saxon Jewellery*. London, 1950.

" 'Joe' Bowles," *The Publishers' Weekly*, Jan. 27, 1934, p. 406

Kandinsky, Wassily. *Concerning the Spiritual in Art*, trans. with intro. by M. T. H. Sadler. New York, (1914) 1977.

Kaplan, Wendy. *"The Art That is Life": The Arts and Crafts Movement in America, 1875-1920*, exh. cat., Museum of Fine Arts, Boston. Boston, 1987.

Kelley, Edith Summers. "Helicon Hall: An Experiment in Living," *The Kentucky Review* 1, no. 3 (Spring 1980), pp. 29-51.

Keystone Special Correspondent, "Indianapolis - Mrs. Bowles Again Winner of Jewelry Design Prize," *The Keystone* 48 (Mar. 1921), p. 253.

Kohlman, Rena Tucker. "Her Metalcraft Spiritual," *International Studio* 80 (Oct. 1924), pp. 54-57.

————————. "Indiana Keramic Club Work at Herron Art Institute," *Indianapolis News*, May 20, 1915.

Kurland-Zabar. *Reflections: Arts and Crafts Metalwork in England and the United States*, exh. cat. New York, 1990.

Lamb, F.S. "Arts and Crafts Exhibition," *Art and Progress* 1, no. 4 (Feb. 1910), pp. 95-97.

Lears, T. Jackson. *No Place of Grace: Antimodernism and the Transformation of American Culture 1880-1920*. New York, 1981.

Long, Florence Webster. "Local Woman Engaged in Designing a Golden Service Set for Morgan," *Indiana Daily Times* 27, no. 105 (Sept. 10, 1914).

MacFadden, David Revere (ed.). *Scandinavian Modern Design 1880-1940*. New York, 1982.

Marshall, F. H. *Catalogue of the Jewellery: Greek, Etruscan & Roman in the Department of Antiquities, British Museum*. London, (1911) 1969.

Marter, Joan M., Roberta K. Tarbell, and Jeffrey Wechsler. *Vanguard American Sculpture*. Rutgers, N.J., 1979.

"Maude Adams to Use Real Silver Props," *The Chicago Tribune*, June 5, 1910, section 9.

"Maude Adams to Use Weapon," unidentified newspaper clipping, Janet Payne Bowles Archives, Indianapolis Museum of Art.

McNault, Aletha V. "Some Indiana Art Exhibition Impressions," *Indianapolis News*, Mar. 8, 1924.

"Metal Work by Mrs. Bowles," *Art News* 23, no. 13 (Jan. 1925), p. 2.

Moffatt, Frederick C. *Arthur Wesley Dow (1857-1922)*, exh. cat., National Collection of Fine Arts, Smithsonian Institution. Washington, D.C., 1977.

Morehouse, Lucille E., in *The Indianapolis Star*: "State Fair Judge in Art Gives Praise to Hoosier Talent," Sept. 6, 1921; "Local Woman Writes of Indianapolis Goldsmith," Oct. 19, 1924, part 2; "Danish Silversmith's Work on Exhibition at Institute," May 17, 1925; "Woman's Building Houses Works of Art for State Fair," Sept. 7, 1925; "Handicraft Exhibit Here is Artistically Displayed," Dec. 13, 1925; "State Fair Displays Art Work of Hoosiers," Sept. 6, 1926; "1935 Craft Exhibition Largest in Many Years," Mar. 24, 1935; "School Art Exhibit Proof of Influence," Mar. 27, 1935; "Four Meritable Shows at Local Art Galleries," Apr. 28, 1935.

Mourey, Gabriel, "Studio-Talk: Paris," *International Studio* 70 (Mar. 1920).

A National Dictionary of Workers in the Artistic Crafts, National Society of Craftsmen, New York, 1909-1910.

"National Society of Craftsmen Exhibition," *International Studio* 39, no. 156 (Feb. 1910), pp. XCVII-XCVIII.

"A New Metal," *Jewelers' Circular Keystone* 61 (Aug. 3, 1910), p. 65.

New York, The Metropolitan Museum of Art. "Japanese Craftsmen," *Bulletin of The Metropolitan Museum of Art* 3, no. 5 (May 1908), p. 99.

New York, National Arts Club. *Exhibition of Articles in Gold and Silver*, exh. cat. New York, 1899.

New York Times: "Mr. Gruelle on Modern Art," Aug. 11, 1895, part 4; "Upton Sinclair's Colony to Live at Helicon Hall," Oct. 7, 1906, part 3; "Fire Wipes Out Helicon Hall," Mar. 17, 1907, part 2; "To Investigate Helicon Hall Fire," Mar. 18, 1907; "Sinclair Colony Censured," Mar. 22, 1907; "Saratoga Mourns for Spencer Trask," Jan. 4, 1910.

Nielsen, L. C. *Georg Jensen, An Artist's Biography*. Copenhagen, 1921.

Oman, C. C. *Catalogue of Rings, Victoria and Albert Museum, Department of Metalwork*. London, 1930.

Pond, Theodore Hanford. "The Arts and Crafts Exhibition at the Providence Art Club," *House Beautiful* 66 (July 9, 1901), pp. 98-101.

The Portfolio Club, *Constitution, Officers, Committees, Members and Scheme of Exercises, 1890-91*, Portfolio Club archives, Indianapolis.

Rathbone, R. LL. B. *Simple Jewellry*. New York, 1910.

Robertson, Bruce. "Frederic A. Whiting: Founding the Museum with Art and Craft," in Evan H. Turner, ed., *Object Lessons, Cleveland Creates an Art Museum*. Cleveland, 1991.

Roth, Linda Horvitz, ed. *J. Pierpont Morgan, Collector, European Decorative Arts from the Wadsworth Atheneum*, exh. cat., Wadsworth Atheneum. Hartford, Conn., 1987.

Rubenstein, Charlotte Streifer. *American Women Sculptors: A History of Women Working in Three Dimensions.* Boston, 1990.

Schilpp, Paul Arthur, ed. *The Philosophy of John Dewey,* 2d ed. New York, 1951.

Schorer, Mark. *Sinclair Lewis, An American Life.* New York, 1961.

Seegmiller, Wilhelmena. "The Arts and Crafts Movement in Indianapolis," *Brush and Pencil* 4 (Chicago, 1899), pp. 213-21.

Shapiro, M. "Hoosier Salon Names 2 Judges," *Indianapolis Star,* Jan. 12, 1969.

Shifman, Barry. "Brandt Steele, Indianapolis Arts and Crafts Designer and Potter," *Traces,* forthcoming (Winter 1994).

_____. *Brandt Steele, Indianapolis Arts and Crafts Designer and Potter,* exh. cat., Indianapolis Museum of Art, Indianapolis. Forthcoming (1994).

Shifman, Barry, and Robert M. Taylor, Jr. "Utility Embellished by Skilled Hands: The Arts and Crafts Movement in Indianapolis and Vicinity," *Traces,* forthcoming (Winter 1994).

Shortridge Daily Echo (or *Daily Echo,* or *Shortridge Summer Echo*): "Arts and Crafts," Nov. 22, 1905; "William Morris Society," Jan. 22, 1906; "The Birthday of William Morris Observed," Mar. 12, 1906; "William Morris Society," Feb. 18, 1907; "Craft Work," Dec. 11, 1907; "Art Specimens to Go Abroad," Mar. 2, 1908; "Miss Dye to Talk on Ruskin," Mar. 17, 1908; "Morris Society," Mar. 20, 1908; "Manual Training at Shortridge," Apr. 22, 1908; "Gem Counterfeiters Will be Exposed," Oct. 25, 1909; "Mr. Wade Gives Talk on Diamonds," Nov. 9, 1909; "Collection of American Pottery," Feb. 28, 1910; "Mr. Harry E. Wood Entertains School," Oct. 6, 1910; "Official Notices," Feb. 20, 1912; "Freshmen Hear Talk on Art Metal Work," Apr. 11, 1912; "Art Department Notes," Oct. 4, 1912; "Mr. Frederick A. Whiting to Address the School," Nov. 7, 1912; "Art Metal," Feb. 13, 1913; "Notice," Sept. 24, 1914; "1915 Exposition Is Heralded by Dr. Fisher," Dec. 10, 1914; "Shortridge Is Honored Through Miss Selleck," Dec. 21, 1914; "Art Department Has Many Visitors," Oct. 25, 1916; "Member of Faculty Is Author of Book," May 24, 1917; "Convention of Pottery Experts Soon," Feb. 5, 1918; "Indiana Art Exhibit Attracts Attention," Mar. 25, 1919; "Art Appreciation Club to Be Formed," Jan. 20, 1920; "Art Appreciation Club," Apr. 6, 1920; "Art Metal Department Asked to Exhibit Work," May 24, 1920; "Art Metal Pupils Who Send Work to the Exhibit," May 31, 1920; "Articles by Mr. Wade in Jewelers' Circular," Nov. 18, 1920; "Shortridge Teacher Receives High Honors," Jan. 26, 1921; "The Art Appreciation Club," Mar. 16, 1921; "Jewelry Exhibition Evokes High Praise," Mar. 25, 1921; "Art Appreciation Club Meets," May 4, 1921; "Prizes Awarded For Jewelry Exhibition," May 27, 1921; "Jewelry Work in N. Y. Exhibit," June 3, 1921; "Psychological Test Used by Mrs. Bowles," Sept. 22, 1921; "Explanation of Courses in Art Department," Dec. 6, 1921; "Art Club Discusses Applied Psychology," Feb. 8, 1922; "Craft Work Exhibited at Herron Institute," Mar. 14, 1922; "Art Notes," Apr. 26, 1922; "Jewelry Department Busy," May 12, 1922; "Art Students Win in State Fair Exhibition," Sept. 14, 1922; "Art Notes," Oct. 13, 1922; "Art Appreciation Club," Oct. 25, 1922; "Mrs. Bowles Speaks on New Russian Art," Jan. 3, 1923; "Jan Bowles Plans Interesting Trip," May 2, 1923; "Art Appreciation Club," May 8, 1923; "New Course Offered in Art Department," May 21, 1923; "Art Notes," May 25, 1923; "Art Notes," June 1, 1923; "Art Teacher Speaks on Art of New York," Jan. 8, 1924; "Miss Bowles Had a Collection...," Mar. 7, 1924; "Art Appreciation Club," Mar. 11, 1924; "Teachers and Pupils Display Art Works," Mar. 13, 1924; "Mrs. Bowles...," Mar. 26, 1924; "Mrs. Bowles Speaks of Jewelry in Detroit," May 26, 1924; "Jewelry Exhibition Is of Exceptional Merit," May 28, 1924; "Janet Payne Bowles Honored by Critic," Oct. 22, 1924; "Miss Selleck's Death Is Deeply Felt by All Indianapolis," Nov. 17, 1924; "Mrs. Bowles...," Dec. 12, 1924; "A Series of Twelve...," Dec. 16, 1924; "Shortridge Jewelry to Be on Exhibition," Dec. 17, 1924; "Woodcut Exhibit Is Visited by Art Club," Feb. 25, 1925; "Mrs. Bowles Receives Certificate of Merit," Mar. 3, 1925; "Mrs. Bowles Had a Collection...," Mar. 3, 1925; "Correction," May 27, 1925; "Members of Faculty Reveal Summer Plans," June 10, 1925; "Short-

ridge Teacher Attends Art Exhibit," Sept. 17, 1925; "Mrs. Bowles Takes Trip During Vacation," Jan. 6, 1926; "Mrs. Bowles Does Art Work Abroad," Sept. 15, 1926; "Indianapolis Artists' Exhibition at Herron," Mar. 8, 1927; "Photograph Collection Seen in Jewelry Shop," Apr. 26, 1927; "Mrs. Janet Bowles Starts Workmanship Guild," May 17, 1927; "Shortridge Awarded Prize at State Fair," Sept. 19, 1927; "Mrs. Bowles Visits Moscow When Abroad," Sept. 26, 1927; "Art Appreciation Will Meet," Oct. 3, 1927; "Jewelry Exhibit Is Very Extraordinary," May 24, 1928; "Mrs. Bowles Grants Second Interview," Sept. 21, 1928; "Art Appreciators to Hold Election Today," Sept. 24, 1928; "New Jewelry Shop Is One of the Best," Nov. 22, 1928; "Shortridge Teachers Take Vacation Trips," Jan. 9, 1929; "Mrs. Bowles Works Shown in New York," Jan. 14, 1930; "Mrs. Bowles to Talk," Apr. 10, 1930; "Pottery Class Will Exhibit Wednesday," Apr. 29, 1930; "Art Teachers Plan Annual Exhibition," May 23, 1930; "Pottery Classes Do Interesting Work," Oct. 8, 1930; "Artists Exhibition Points to New Mark," Mar. 9, 1931; "Art Class Displays Glazed Pottery Work," Apr. 15, 1931; "Roda Selleck Art Gallery," Apr. 6, 1932; "Art Appreciation Club Seeks New Members," Dec. 1, 1932; "Jewelry Students See Demonstration," Apr. 13, 1933; "Mrs. Janet Bowles Visits in S. America," Sept. 13, 1933; "Mr. Geisler to Give Talk on Jewels," Nov. 7, 1934; "Jewelry Is Displayed at Herron Institute," Apr. 18, 1935; "Feature Tells of Shortridge Exhibits," Mar. 28, 1935; "Pottery Class Shows Work in Display Case," Feb. 17, 1936; "Pottery and Jewelry Sold to Aid War Chest," May 5, 1942; "Shortridge Loses Janet Bowles," June 18, 1942; "Services Held for Mrs. Janet P. Bowles," July 23, 1948.

Sikorski, Jerome E. "Out of Indianapolis: Janet Payne Bowles, Goldsmith," M.A. thesis, Wayne State University, 1974.

Sinclair, Andrew. *Corsair: The Life of J. Pierpont Morgan.* Boston, 1981.

Stewart, Lotys Benning, "They Achieve, Minds and Hands of Indianapolis Women at Work for Others," *The Indianapolis Star*, Mar. 29, 1942, part 4.

Strömbom, Sixten. *Swedish Tercentenary Art Exhibit 1937-1938*, exh. cat. Stockholm, 1937.

Strong, D. E. *Greek and Roman Gold and Silver Plate.* London and New York, (1966) 1979.

Taylor, Robert M., Jr. "The Arts and Crafts Society in Indianapolis," *Traces*, forthcoming (Winter 1994).

Thompson, Susan Otis. *American Book Design and William Morris.* New York, 1977.

Ulehla, Karen Evans. *The Society of Arts and Crafts, Boston, Exhibition Record 1897-1927.* Boston, 1981.

Warkel, Harriet. "Joseph Moore Bowles and *Modern Art*," *Traces*, forthcoming (Winter 1994).

Washington, D.C., Smithsonian Institution. *Georg Jensen Silversmithy*, exh. cat. Washington, D.C., 1980.

White, Esther Griffin. "Some Indiana Bookplates," *The Craftsman* 4 (May 1903), pp. 93-95, ill.

Whiting, Frederic Allen. "Frederic Allen Whiting Papers," Archives of American Art, Washington, D.C., roll 429, frame 655.

Wood, Harry E. *Progressive Problems in Mechanical Drawing.* Chicago, 1927.

——————. "History of Art, Practical Arts and Vocational Education in the Indianapolis Public Schools," unpublished manuscript, 1950.

Wood, Harry E., and James H. Smith. *Prevocational and Industrial Arts.* Chicago, 1919.

Wright, Gwendolyn. *Moralism and the Model Home.* Chicago, 1980.

Yeh, Susan Fillin. "Introduction," and "Innovative Moderns: Arthur G. Dove and Georgia O'Keefe," in "Special Section: Abstraction Before Abstract Expressionism: American Art, 1900-1945," *Arts Magazine* 56 (June 1982), pp. 67-72.

Index

Adams, Maude, 16, 37, 50, 54, 66

Addams, Jane, 29

Aldrich, Thomas Bailey, 48

Alexander, John, 16

American Federation of Arts, 17

Art Center (New York), 61, 63

Art Deco, 22

Art Appreciation Club (Indianapolis), 20-21, 39

Art Association of Indianapolis, 11, 12

Art Institute of Chicago, School of, 28-29

Arts and Crafts Society (Chicago), 49

Arts and Crafts Society (Indianapolis), 17

Atlan Ceramic Art Club (Chicago), 28

Barnum, Mary, 28

Beardsley, Aubrey, 12

Behrens, Peter, 18

Berenson, Bernard, 22

Binns, Charles F., 40

Blakeslee, Mary, 28

Book of Kells, 48

Bossilini, J., 21, 56

Bowles, Jan, 8, 14, 22, 32, 34, 39, 40, 42, 47

Bowles, Joseph Moore, 11-12, 14, 30, 32, 34, 35, 37, 40, 48, 49, 59

Bowles, Mira, 8, 14, 22, 32, 34, 39, 40-41, 42, 43, 47, 56

Braque, Georges, 60

Carson, Jane, 28

Cellini, Benvenuto, 22

Celtic art, 48, 49, 50, 51, 56, 66

Citizens' Education Society (Indianapolis), 16

Clarke, Casper Purdon, Sir, 15, 37

Columbian Exposition (Chicago), 48

Copeland, Elizabeth E., 28

Cosio, Clemencia, 28

Coultas, Wilhemina, 28

Dewey, John, 14, 15, 22, 34, 35, 38, 41, 60

Donatello, 22

Dove, Arthur, 60

Dow, Arthur Wesley, 49, 59, 60

Dunstan & Company, 39

Dye, Charity, 18

Exposition Internationale des Arts Décoratifs et Industriels Modernes (Paris), 22

Forest Press, 15

Forsyth, Clarence, 11

Gilman, Charlotte Perkins, 33-34

Goldman, Emma, 34

Gorham (New York), 20

Gossamer to Steel, 32-33, 39

Grueby pottery, 18

Hampshire pottery, 17

Handicraft Guild of Indiana, 17

Helicon Hall, 14-15, 30, 33, 34

Hoffmann, Josef, 18

Home Colony, *see* Helicon Hall

Hussey, Mary Elaine, 49

Indiana Keramic Association, 17

Indianapolis High School, *see* Shortridge High School

Indianapolis Museum of Art, *see* John Herron Art Institute

James, William, 12, 15, 30, 31, 32, 34, 35, 38, 40, 60

Jensen, Georg, 57, 61, 64

John Herron Art Institute (Indianapolis Museum of Art), 16, 17, 18, 19, 20, 21, 22, 38, 39, 52, 57

John Herron Art School (Indianapolis), 17

Kalo Art-Craft Community (Chicago), 29

Kalo Shop, 28, 29

Kelmscott Chaucer, 18

Kelmscott Press, 12, 31, 48

Knight, Mary C., 28

Koehler, Florence D., 28

Kohlman, Rena Tucker, 38, 61

Laurent, Robert, 60

Lavaron, Leonide C., 28

Lewis, Sinclair, 15

Lieber, H., Company, 11

Lindisfarne Gospels, 48

Little Room (Chicago), 28

Marblehead pottery, 17

McClure's Magazine, 14, 32

Metropolitan Museum of Art, 14, 15, 35, 50, 52

Michelangelo, 22

Mission Oak, 6

Modern Art, 12, 14, 30

Moravian pottery, 17

Morgan, J. Pierpont, 15, 37, 52, 54, 66

Morgan, William de, 18

Morris and Company, 18

Morris, William, 6-7, 11, 12, 18, 22, 31, 42, 48

Moser, Koloman, 18

National Arts Club (New York), 16, 49

National League of Handicraft Societies, 49

National Society of Craftsmen (New York), 15-16, 37, 49, 50, 51

Newcomb pottery, 17

Okabe, K., 50

Olbrich, Joseph, 18

Panama-Pacific International Exposition (San Francisco), 28, 56, 66

Payne, Gavin, 38

Pewabic pottery, 17

Picasso, Pablo, 60

Portfolio Club (Indianapolis), 11-12, 18, 22, 38, 39, 42, 48

Potter, Horace E., 48

Prang, Louis, and Company, 12

Pratt, Jennette, 28

Preston, Jessie M., 28

Providence Art Club, 48

Rathbone, R. LL. B., 49, 51

Reade, Christa M., 28

Riemerschmid, Richard, 18

Rogers, Bruce, 12, 48

Rookwood pottery, 17, 18

Ruskin, John, 6-7, 11

Saint Peter's (Rome) 21

Santa Annunziata (Florence), 21

Second Epistle of John, The, 14, 31, 48; pl. 2

Seegmiller, Wilhelmina, 18

Selleck, Roda, 11, 17-18, 19, 21, 52

Seldridge pottery, 18

Shaw, Josephine Hartwell, 28

Shortridge High School, 16, 17, 18, 19, 20, 30, 38, 43, 52

Sikorski, Jerome, 8, 47, 56

Sinclair, Upton, 14, 33

Smedley, Ruth, 28

Society of Arts and Crafts (Boston), 14, 17, 18, 31, 32, 37, 48, 49, 52, 60

Society of Western Artists, Indiana Chapter of, 17

Steele, Brandt, 17

Stella, Joseph, 60

"Step-Off, The," 22, 42-43, 47

Stickley, Gustav, 6, 32

Stone, Arthur J., 48

Teco pottery, 17, 18

Trask, Spencer, 15-16, 37, 50

True Story of the Christmas Tree, The, 39

Van Briggle pottery, 17, 18

Velde, Henry van de, 18

Volkmar pottery, 17

Watkins, Mildred G., 28

Welles, Clara Barck, 28-30

Welles, George S., 29-30

Whiting, Frederic Allen, 18, 37, 38, 50, 52

Willard, Frances, 29

William Morris Society (Indianapolis), 18

Wilson, Henry, 49

Wood, Harry E., 19, 38, 52

Workmanship Guild (Indianapolis), 6, 21, 41

Wynne, Madeline Yale, 28, 31-32, 49

Zimmermann, Marie, 28

Zorach, William, 60

Edited by Elizabeth A. Pratt

Designed by Elizabeth Finger

Typeset by Craftsman Type Inc., Dayton, Ohio

Printed by Meridian Printing, East Greenwich, Rhode Island